WOMEN'S ART WORK

TO ANNIE, HOLLY, EMILIA, AND MARGARET,
FOUR WOMEN WHOSE FRIENDSHIP, HARD WORK,
AND CREATIVITY HELPED TO MAKE THIS BOOK —S.B.

TO YOUNG ARTISTS, I HOPE THIS BOOK INSPIRES
YOU TO CREATE AND MAKE YOUR SPACE IN THE
ART WORLD —M.T.

Cataloging-in-Publication Data has been applied for
and may be obtained from the Library of Congress.

ISBN 978-1-4197-4118-0

Text copyright © 2019 Sophia Bennett
Illustrations copyright © 2019 Manjit Thapp
Interviews copyright © 2019 the individual artists

First published in 2019 by order of the Tate Trustees by Tate Publishing,
a division of Tate Enterprises Ltd, Millbank, London SW1P 4RG.

Printed and bound in Italy
10 9 8 7 6 5 4 3 2 1

Abrams Books for Young Readers are available at special discounts
when purchased in quantity for premiums and promotions as well as fundraising
or educational use. Special editions can also be created to specification. For details,
contact specialsales@abramsbooks.com or the address below.

Abrams® is a registered trademark of Harry N. Abrams, Inc

ABRAMS The Art of Books
195 Broadway, New York, NY 10007
abramsbooks.com

WOMEN'S ART WORK

MORE THAN 30 FEMALE ARTISTS WHO CHANGED THE WORLD

WRITTEN BY SOPHIA BENNETT
ILLUSTRATED BY MANJIT THAPP

ABRAMS BOOKS FOR YOUNG READERS
NEW YORK

CONTENTS

FOREWORD

Until very recently, the story of art told in the Western world has been focused almost exclusively on the lives and work of male artists. Whether in museum collections, gallery exhibitions, or art history textbooks, women have been pushed to the margins and forgotten. When Tate first opened its doors in 1897 only 5 out of 253 pictures on display were by women. It is only in recent decades that we have started to shine a light on a richer, more balanced history, to hear the experiences and celebrate the creativity of women in all their diversity.

Of course, this creativity is not in itself anything new. Like all humans, women have been making art for millennia. From the women who first started making devotional paintings around three thousand years ago to Lubaina Himid, who in 2017 became the first woman of color to win the Turner Prize, there is an unbroken line of great artists who just happen to be women. Centuries of discrimination have meant that many have not received the recognition their talents merited or even the opportunity to study, work, or fulfill their true creative potential. The lives of many of these artists have been forgotten; the names of many more were never recorded.

Thankfully, over recent years that has started to change. Just as our wider society has slowly been reshaped over the past century to be more inclusive of women and other diverse identities, so their representation in the arts has gotten ever stronger.

This has not happened by chance, but through the pioneering work of artists, activists, curators, and critics, women have been able to break down the boundaries that once held them back, and to make their voices heard. Groups like the Guerrilla Girls, a collective of women artists and art professionals, have used their work to highlight the discrimination and issues faced by women in the art world. Many others have sought to explore issues of identity, sexuality, politics, and history, and by doing so to enrich our understanding of what art is and can be.

This process has allowed us to re-evaluate the work and legacy of women artists from the past, such as Berthe Morisot and Gwen John, who battled against great odds to make their mark in a male-dominated society. It has helped us to redefine the nature of art itself: to see the significance of someone like Anni Albers, whose work would once have been dismissed as the "decorative arts." It has allowed artists such as Joan Jonas and Ana Mendieta to break new ground in exploring how women's bodies can be at the center of artistic expression. And it has allowed the experience of women with diverse identities from around the world to come to the fore, from Cao Fei, examining the rapid transformation of Chinese society in the twenty-first century, to Simryn Gill, whose detailed work explores issues of identity and the power of community.

At Tate, we have been making a big effort to increase the number of women artists in our collection and on display in our galleries, in all their diversity. But while progress has been made, it is clear that much work remains to be done before we can say that there is equality.

This book aims to play a small part in helping reach that goal, by inspiring, informing and supporting the next generation of fearless female artists and their allies. It looks at the many roles played by women in the art world, from curators and conservators working behind the scenes, and tells the stories of some great women artists from the nineteenth century to those working today.

The experience of each of these remarkable women is unique. We also recognize today that artists and individuals may choose to identify in non-binary ways, which we also celebrate. Taken together, this shows us that there is not one "female art," but art produced by a multitude of individuals, each expressing something fundamental about what it means to be human.

That truly is a bigger picture worth celebrating.

Maria Balshaw
Director, Tate

Women's Work

What is art? Is it a painting, a sculpture, a stained-glass window . . . or also a quilt, a pot, a carpet — if it is beautifully made?

For thousands of years anonymous makers have created beautiful objects with great skill and artistry. In the West, weaving, sewing, embroidery, and painting on crockery were considered "women's work," "domestic art," and "craft"—they were not *fine art*, like paintings or sculpture. Instead they were known as decorative arts, and their makers were not usually considered great artists.

This was not true everywhere. In China, decorative arts such as embroidery and calligraphy have for centuries been considered as precious as any painting or sculpture. Islamic art has always highly prized garden design, architecture, and carpet-making. But despite this, the names of most female makers have been lost in history.

Appreciation of what is "great art" is changing across the world, thanks to many of the artists in this book. Anni Albers, Judy Chicago, and Tacita Dean have used traditional craft techniques to express their ideas in ways that are wonderful and new. Their work makes us see the world differently, which is what all great art can do. Now you might find a beautiful Albers woven textile on a gallery wall or a museum room dedicated to Chicago's painted plates or Dean's finely edited films.

Look out for sewing in the work of Louise Bourgeois, Tracey Emin, Anthea Hamilton, or Doris Salcedo. Are Simryn Gill's book-page necklaces art, or craft, or both? And what about the "mobile museums" Dayanita Singh makes to display her photographs?

Today, even the internet can be art. Cao Fei made an interactive project called *RMB City* on the online platform Second Life. The nature of art is always changing, as new artists come along to challenge what was there before. What will women make in the future? We can't wait to find out!

EiLeeN AgaR

1899 - 1991

Eileen Agar could spark your imagination by taking a familiar object and turning it into something strange and new. In addition to painting and making collages, she created sculpture from materials around her, such as a plaster cast of her husband's head, which she wrapped in silk, feathers, beads, and seashells. Is the head masculine or feminine, blindfolded or given a silken skin? How you interpret it is up to you!

Agar was born in Argentina at the very end of the nineteenth century. She described her wealthy childhood in Buenos Aires as "full of balloons, hope, and St. Bernard dogs." When she was eleven her parents moved to England, where her glamorous American mother encouraged her talent for art—as long as she only painted for fun. Agar, however, was determined to become a professional artist.

After art school in London she went to Paris to paint. Here she discovered the surrealists. They believed art and literature should be inspired by subconscious ideas and dreams. Eileen did not entirely agree, but she liked the idea of daydreaming and painting what was inside her head. From then on she combined her love of color with subjects inspired by nature and mythology.

Back in London, Agar was the only British woman chosen for the *International Surrealist Exhibition* in 1936. This led to her work being exhibited around the world. She became friends with Pablo Picasso, Man Ray, Lee Miller, and many other artists and poets who all inspired and influenced each other. You can still see her ideas echoed in fashion magazines today.

Agar's playful approach to life and art can be seen in her famous 1936 *Ceremonial Hat for Eating Bouillabaisse* (a type of fish soup). She made it from an upside-down cork dish featuring an orange plastic flower, two starfish, and a piece from a jigsaw puzzle, among other things. It was typical of Agar: witty, elegant, and rebellious.

"I've lived a good life and it shows through."

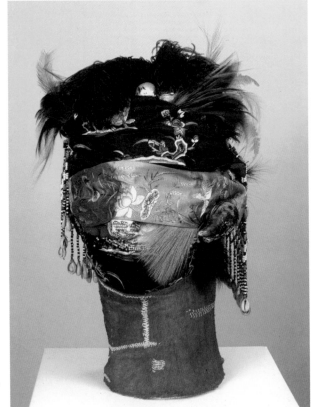

Angel of Anarchy
1936-40

Anni Albers

1899 - 1994

Anni Albers took an ancient craft and raised it to the status of fine art. Looking at her colorful, experimental textiles now, we often take for granted many of the elements she invented.

Born in Berlin to a wealthy assimilated Jewish family, Albers chose not to follow in her mother's footsteps and become a housewife. Instead, she attended the groundbreaking Bauhaus School of Design in Weimar, Germany, in 1922. She wanted to be a painter but reluctantly accepted a place in the weaving workshop, in which most female students were enrolled. The resourceful Albers, however, fell in love with the possibilities of working on a loom.

Albers was fascinated by thread and what it could do. Unlike traditional weavers in Europe, who wove tapestries to someone else's design, Albers made up her textiles as she went along, inspired by the materials in her hands. Taking weaving to a new level, she learned about the ancient techniques used by weavers in Peru and combined them with modern ideas from abstract artists such as Paul Klee, who was one of her teachers at the Bauhaus.

"Klee said to take a line for a walk. Well I shall take a thread for a walk . . ."

The result was innovative fabrics that could be hung on the wall as art. Albers was also in demand to make practical objects like screens and curtains, incorporating new materials such as cellophane.

When the Nazis closed the Bauhaus school down in 1933, Albers and her husband Josef, also an artist, emigrated to America to teach at Black Mountain College in North Carolina. Their ideas inspired generations of artists, craftspeople, and designers. Anni's books, *On Designing* and *On Weaving*, are still used in art schools today.

Albers was the first textile artist to have a show at the Museum of Modern Art in New York in 1949—three years after Georgia O'Keeffe's influential exhibition. She visited the communities in South America that had inspired her, spending time with folk weavers in Mexico. In 1963, she turned to printmaking, which also fired her imagination. She believed that art was important to human existence.

"Creating is the most intense excitement one can come to know."

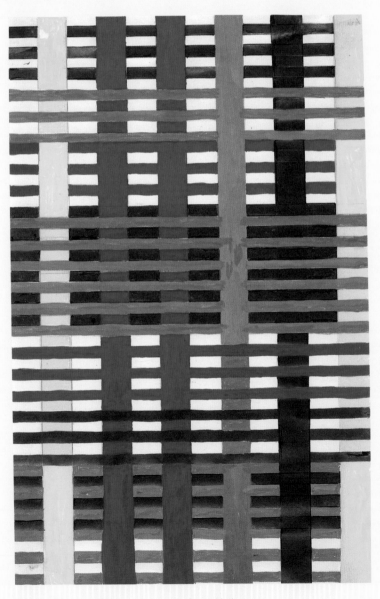

Study for a 1926 unexecuted wall hanging

Louise Bourgeois
1911 - 2010

What is it like to grow up in wartime and to suffer loss and betrayal in your childhood? What is it like to leave home and create a new life in another country? How do you balance being a wife and mother, and an artist? These are some of the questions that Louise Bourgeois answered through her art.

Bourgeois was born in Paris on Christmas Day, 1911, to a family of tapestry restorers. She experienced the trauma of the First World War as a young child, and visited her father on the front after he was wounded in 1916. As a young girl, she helped draw in missing parts of tapestries that needed to be rewoven. Her father wanted her to continue in the family business, but Bourgeois preferred the study of mathematics and philosophy.

She spent much of her teens caring for her ill mother, who suffered from a chronic lung condition. When Bourgeois was twenty, her mother died, and her feelings of loss and depression influenced her turn to art. Throughout her life, she captured her anger, guilt, and sense of abandonment in her diaries. The memories and emotions of her past fueled her work.

In 1938, Bourgeois met and married an American art historian, Robert Goldwater, and emigrated to New York. Balancing family life with the need to create, she carved her first sculptures out of wood on the roof of the apartment building where she and her family lived. Bourgeois was fascinated by the ways in which feelings of anxiety and vulnerability were expressed through the body. Though her first solo exhibition was in 1945, it wasn't until her retrospective exhibition in 1982 that she was finally celebrated as a great artist.

Bourgeois's later work grew larger in scale. In her room-sized "Cell" sculptures, she incorporated objects that belonged to her along with forms that she created out of various materials, like marble, glass, fabric, and wax. She also began using her own clothing as raw material for sculpture and cloth drawings.

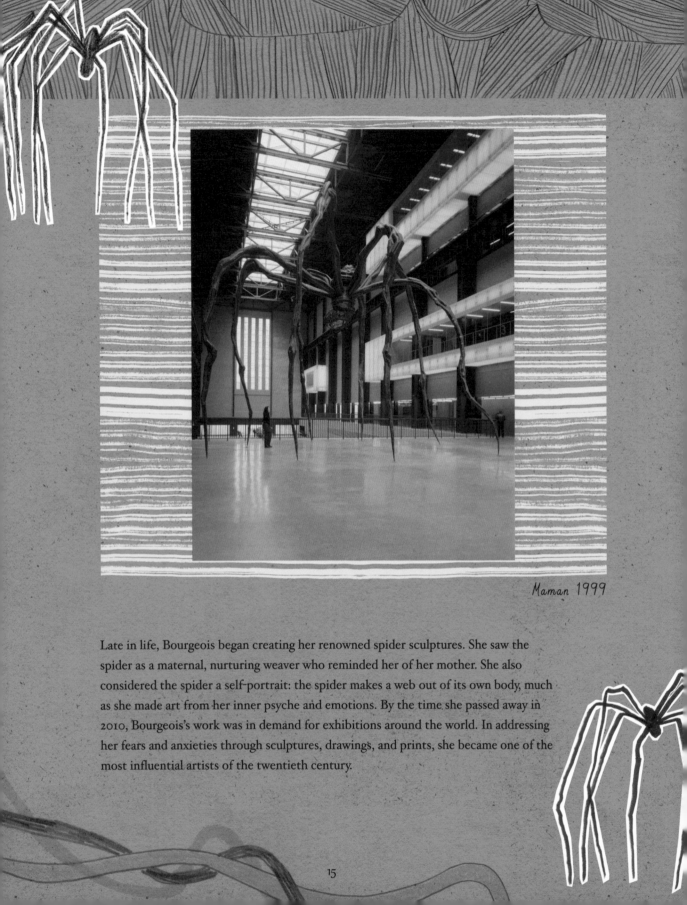

Maman 1999

Late in life, Bourgeois began creating her renowned spider sculptures. She saw the spider as a maternal, nurturing weaver who reminded her of her mother. She also considered the spider a self-portrait: the spider makes a web out of its own body, much as she made art from her inner psyche and emotions. By the time she passed away in 2010, Bourgeois's work was in demand for exhibitions around the world. In addressing her fears and anxieties through sculptures, drawings, and prints, she became one of the most influential artists of the twentieth century.

PIONEERS

Great women have been making art throughout history. Wherever you go, however far back you search—if you look, you will find them. History has had a tendency to forget them, but gradually the bigger picture is being restored!

Guan Daosheng (1262–1319) was a poet and calligrapher best known for her beautiful paintings of bamboo. Even an inch or two of silk painted by her was worth a fortune. Known as Lady Guan, she was greatly favored by the Emperor Kublai Khan and is the most famous female artist in the history of China.

Levina Teerlinc (1510–1576) was a Flemish miniaturist who became one of the most important painters at the court of Henry VIII. Her miniatures of the king and all his children glow with color and life. She probably also designed the Great Seal of England for Mary I.

Sofonisba Anguissola (c.1532–1625) grew up in Italy, where her work was admired by Michelangelo. She was a lady-in-waiting and art tutor to Queen Elizabeth of Valois and court painter to Philip II before becoming a leading portrait painter. The great Renaissance art historian Vasari described her work as "rare and very beautiful."

Artemisia Gentileschi (1593–1654) was one of the great painters of the Italian Baroque period. Forbidden to go to art school, she learned in her father's workshop. She specialized in painting stories from classical legends and the Bible, with women as the main protagonists. Dukes and kings collected her paintings.

Elisabeth Louise Vigée le Brun (1755–1842) was court painter to Marie-Antoinette. Like Gentileschi, she learned to paint not only from her father but also by copying works of art in galleries. She became so brilliant that Louis XVI allowed her into the Académie Royale. After the French Revolution in 1789, she painted the aristocrats of Italy and Russia and remained one of the most successful portrait painters of her day.

Julia Margaret Cameron (1815–1879) was a pioneering photographer. At age forty-nine she was given one of the earliest cameras ever made as a gift from her daughter. She took photographs of many Victorian celebrities. Unlike her male contemporaries, she liked to leave little imperfections in the finished photograph, to show how it was made.

Sonia Boyce

Born 1962

Sonia Boyce is a contemporary British artist who lives and works in London. Her work is important in representing the black female figure and analyzing how black women's bodies are perceived.

Boyce originally wanted to be a dancer, but a teacher at school noticed her talent for drawing. In the early part of her career her art was political. She was a member of the British black arts movement of the 1980s, where she focused on portraying the experience of black women in the United Kingdom, including her own. Boyce took images of black people created by the mainly white society she knew such as Hollywood films and old racist cartoons and using pastel drawings and photographic collages, she contrasted these with her own self-image, which was much more complicated and powerful.

From 1990, Boyce changed her direction to collaborate more with other artists and members of the public. Instead of basing herself in a studio, she now travels around to bring people from different backgrounds together. Using improvisation, video, installations, photography, and more, she creates work within communities across the United Kingdom.

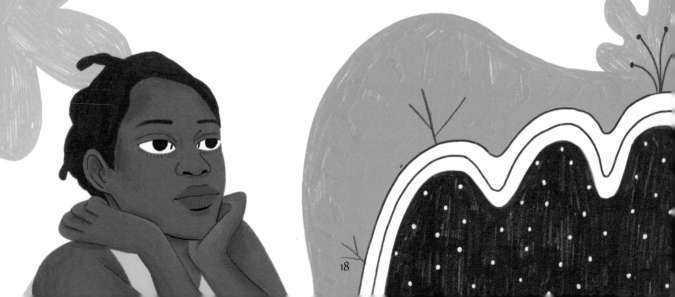

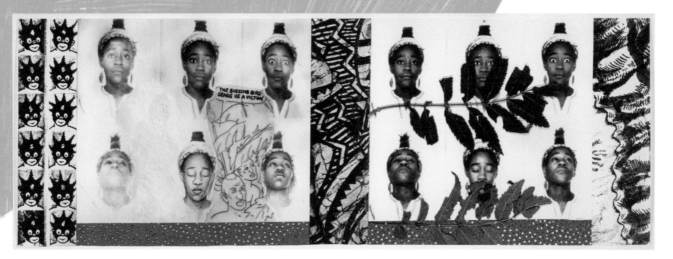

From Tarzan to Rambo: English Born "Native" Considers her Relationship to the Constructed/ Self Image and her Roots in Reconstruction 1987

In 2017, during a larger project with the Manchester Art Gallery called *The Gallery Takeover*, Boyce organized an evening of performance inspired by some of the works. After talks with the staff, she arranged for John Waterhouse's painting *Hylas and the Nymphs* 1896 to be temporarily taken off the wall. It was replaced with a text asking the public what they thought about the painting and the representation of the female body in art. This caused a controversy, but at the same time raised awareness of the behind-the-scenes decisions that galleries make about which artworks to hang that the public rarely get to hear about.

In 2018, Boyce was working on the longest public artwork ever made in the United Kingdom: a 1 mile mural for Crossrail. It will include almost two hundred stories from and about people who live in the Royal Docks, London, near where she grew up.

"Do it because you're thinking it and feeling it and it's got to be expressed. So just get on with it."

CLAUDE CAHUN

1894 - 1954

A severe and compelling face stares out at us from a series of black-and-white photographs. Is the subject male or female, both or neither? The more we look, the more we wonder.

> "Shuffle the cards. Masculine? Feminine? It depends on the situation. Neuter is the only gender that always suits me."

Claude Cahun was born into a literary Jewish family in France in 1894. Her birth name was Lucy Schwob, but she chose to be known as Claude because it's one of the few French names that can be both male and female. Cahun spent her life exploring sexuality and identity. She used the feminine pronoun when referring to herself in French so we will do the same, but with respect for her choice to remain genderless.

Cahun's best friend at school was Suzanne Malherbe, who became her life partner and stepsister. Malherbe worked as an artist under the name Marcel Moore. Together they went to Paris in the 1920s, where they joined the surrealist set. Cahun was mainly a writer, but she loved art and theater too. She also posed for hundreds of photographs that gave new meaning to accepted ideas of masculinity and femininity.

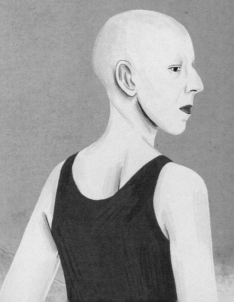

In these, she often appears with her head shaved. In one, she's a circus strongman, with cupid-bow lips and hearts on her cheeks. In another, she seems to have transformed into a stone pillar with arms reaching out toward the sky. Each time, she doesn't turn into someone else but reveals another layer of herself.

There was a time when Cahun and Moore did disguise themselves. Living on the Channel Island of Jersey, off the coast of France, during the Second World War, they secretly worked for the resistance, while pretending to be two harmless middle-aged ladies. They were caught and nearly killed before the Allies rescued them in 1945. The Nazis, however, destroyed much of her work.

Who took the surviving photographs? We assume it was Moore but can't be sure. In fact, we know little about Cahun beyond what the photographs show. Though she wrote a memoir, she used it to challenge ideas about herself, not explain them.

We do know that throughout her life she was extremely brave and endlessly curious. To be like Cahun is to take nothing for granted. It's to stand up for what you believe in, and to be yourself, whoever that self may be.

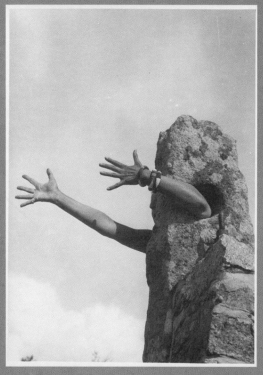

I Extend My Arms 1931 or 1932

Judy Chicago

Born 1939

In 1979, a groundbreaking artwork called *The Dinner Party* was exhibited at the San Francisco Museum of Modern Art. It was the work of Judy Chicago and an important milestone in feminist art.

The Dinner Party celebrates over a thousand great women in Western history. It took Chicago five years to make it, with the help of nearly four hundred (mostly female) contributors. At the time over one hundred thousand people came to see it. Many wrote to her to say it had changed their lives.

Chicago was born Judy Cohen in 1939, but she legally changed her name when she launched herself as a feminist artist. She used painting, sculpture, and installations to express her experience as a woman, but Chicago realized that in order to be taken seriously as an artist she needed to reintroduce women into art history.

In addition to making art, Chicago has encouraged communities of women to come together and support each other. Almost fifty years ago, Judy Chicago was shedding light on women's movements, about issues that are still important for women today. Finally, the world has caught up with her.

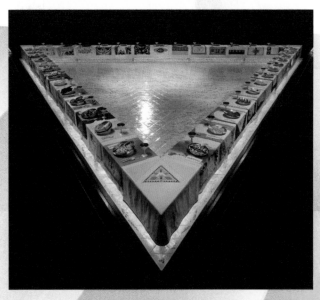

The Dinner Party
1974-79

Why do you think making art is important?

I have always thought that art has an important role in helping us "see" aspects of the world in which we live that we might not otherwise notice or understand.

What advice would you give to your twelve-year-old self?

I would tell myself what I learned when I was thirteen and my father died. He was a wonderful man who taught me a lot, including the idea that I had an obligation to make a contribution to a better world. But he was a Marxist during the McCarthy era, when people like him were demonized. I had to decide then whether I would believe my own experience of my father, or accept what the world was saying. At that point, I made an important decision, one that has guided me throughout my life; that just because "everybody" thinks something, that doesn't make it true. It is important to discover and hold on to one's own truth, even if it isn't popular.

Who was your role model growing up?

When I was very young, my father was my primary role model, but when I joined art school at age five, my role models became the famous artists, most of whom were men. Later in life, I discovered women's history and my foremothers became my role models. Learning about the obstacles they had faced in order for me to enjoy so many rights changed my life.

If you weren't an artist, what would you be?

From when I was very young, I wanted to be an artist and to become part of art history. I cannot imagine any other life.

What is your favorite color, and why?

Purple. I love it.

What inspires you in your life?

Trying to make a difference; that is what my art and my life have been about.

PIONEERS

Edmonia Lewis (c.1844–1907) was a sculptor of African American and Native American descent. She grew up in upstate New York, trained in sculpture, and went to work in Rome in 1865, where she became an international success.

Uemura Shoen (1875–1949) started drawing in her mother's teashop in Kyoto. By fifteen she was exhibiting her paintings there. She specialized in making pitcures of beautiful women known as *bijin-ga*, and depicted numerous ordinary women, including her mother, wearing kimonos in vivid colors walking in nature or doing domestic tasks. She was the first woman to be given the Japanese Order of Culture.

Vanessa Bell (1879–1961) was at the heart of a British artistic community called the Bloomsbury Group. Her sister, Virginia Woolf, became a great writer, while Vanessa was an artist with a distinctive modernist style. You can visit her beautiful, hand-decorated home at Charleston in Sussex, which is now a museum.

Lee Miller (1907–1977) started out as a model in New York. In the 1920s she went to Paris, where she became a surrealist and helped invent the photographic technique called "solarization" made famous by Man Ray. She was a correspondent for *Vogue* in the Second World War, taking iconic photographs of London in the Blitz and the discovery of the concentration camps.

Emily Kame Kngwarreye (c.1910–1996) was born in Alhalkere, near Alice Springs in Central Australia. In her seventies, having learned the craft of batik dyeing, she was introduced to painting in acrylics on canvas. Using her art to express her connection to her homeland, she created over three thousand works in the eight years until she died, averaging one a day.

Elizabeth Catlett (1915–2012), whose grandparents were enslaved, became one of the first students to earn a Master of Fine Arts degree in sculpture from the University of Iowa, in 1940. She settled in Mexico and worked there until her nineties, making sculptures such as *Homage to my Young Black Sisters*, and prints such as *Negro es Bello* ("Black is Beautiful").

Zubeida Agha (1922–1997) was one of the pioneers of modern art in Pakistan. In her twenties, she was the first artist to hold an exhibition there after the formation of the country in 1947. Known as a "colorist," she created bold paintings that helped inspire a new generation.

TACITA DEAN

Born 1965

Tacita Dean uses film (the photochemical kind) to explore people and places.

Film, in Dean's hands, takes on new possibilities. It can be exposed to the light several times inside the camera so that multiple scenes unfold at once on the same piece of film. It can be small and jewel-colored, like a miniature painting, showing the expressions that flick across a face. Or big and bold, shown across six screens in a room, or tall and thin like a monument. Her films make you stop and look closely at details you might not notice normally. They ask you to think, to slow down for a moment.

She also works with her collections of objects from four-leaf clovers to postcards, and with drawing and photography. Often her method is to start with curiosity and see where it takes her.

Did you always know you wanted to be an artist?

Yes, always, unequivocally.

Why do you think making art is important?

When I was on my foundation course in Canterbury College of Art in 1984, there was talk of closing down the art school. I remember we all went into the city to ask people to sign a petition. I always remember one man saying, as he signed, "Well, you have got to have somewhere to do nothing." There's a fragile truth in this. Art comes directly from the self: from the experience and interior life of an individual, and in this sense, it is utterly selfish. This is why I find this question so hard to answer because all answers inevitably appear grandiose. Yet we know art is profoundly important—it is the longest connective thread from our primal selves to who we are now. Trying to make art that is important is doomed to failure because its importance is never really understood in its own time. So my answer to this question is to stay very local. If what you make affects one person in a way you could not have imagined then it is important.

What advice would you give to your twelve-year-old self?

I think my twelve-year-old self advised me quite well. I'm not sure I could have done anything differently. It wasn't a particularly easy road but it was the only one I could have taken.

What advice would you give to young artists?

Concentrate on your work above all else. If your energy goes into your work, the rest will follow. I have encountered many people who have concentrated on their career more than their work and it never ends well. Your work and your creative process really have to be your center—your point of stillness—and everything else emanates from that.

How do you go about making an artwork?

The process of making something is very, very important. For me, it is a journey. I start with an idea, very small and ill formed, and then I take a trip. It is important for me to discover where I'm going rather than to know where. The best work bears no resemblance to how I imagined it would be when I first had the idea. My advice is to trust in the journey and to have trust in your process, however daunting it might sometimes feel along the way.

What is your favorite medium, and why?

I am fighting hard to keep photochemical film and photography available for the next generation. There has been an assumption in the last few years that digital can replace film, but this is not true. Film is a different medium to digital: you make it in a completely different way and how you make a work of art affects what that work becomes. What I love about film is everything that is invisible to me. The word "camera" means room, so a camera is literally a dark room where the light let in changes the salt crystals in the emulsion and then, through chemistry, becomes the image. It is utterly magical. Think what you can do with that magic?

Majesty 2006

Tracey Emin

Born 1963

Tracey Emin is brave, controversial, and one of the best-known people to emerge from the generation of Young British Artists (YBAs) in the 1990s. She is most famous for making art out of a messy bed and a tent embroidered with names.

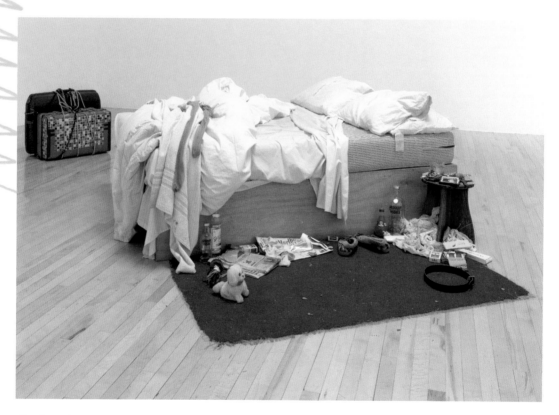

My Bed 1998

Growing up in Margate, on the southeast coast of England, Emin was a rebellious teenager. She went on to study fashion, printmaking, painting, and philosophy at colleges in Kent and London. She then opened a shop with her friend and fellow artist, Sarah Lucas, selling their work.

My Bed was first exhibited in Japan in 1998. It is the artist's actual bed and the area around it after she spent several days there, feeling depressed and unwell. With rumpled sheets and pillows, it is exactly the sort of space many people would choose to change or hide. By recreating it exactly, using the original objects, Emin reveals how vulnerable she was at the time, but is bold in making public something so private. In the plain white space of a gallery, *My Bed* forces you to stop and consider its effect.

Since then, Emin has used printmaking, drawing, sewing, and collected objects to create her pieces, which have been sold and displayed around the world. A recent work for St. Pancras Station in London was a 66-foot-long piece of her handwriting in pink LED light saying, "I want my time with you." A long way from her rebellious teens, she was made Professor of Drawing at the Royal Academy in 2011, one of the first female professors in the academy's history.

To make art like Emin is to take your most private feelings and transform them into images and objects other people can connect with. Not everyone can do this, or would want to, but by expressing her own vulnerability, love, and pain, Emin makes us feel less alone when we have these feelings too.

Cao Fei

Born 1978

Cao Fei grew up in a part of the world that is changing faster than almost any other: the Guandong province of southern China. She focuses on the transformation that fast-growing cities and technology bring to lives of young people.

Her multimedia projects mix fantasy and reality. In *COSplayers*, teenagers fight imaginary battles across the city dressed as their favorite online gaming characters, but in their ordinary lives they feel out of place.

Thanks to the internet, we are all closely connected and can buy whatever we want, but as individuals we can still feel lonely and isolated. Cao Fei makes us wonder at all this progress, and who pays the price.

Why did you start making art?

My parents are artists. I grew up in an artistic family in China. I was able to observe my parents' creative processes since I was little.

COSplayers 2004

How do you go about making an artwork?

When I was little my parents gave me a sketchpad and told me to use it to sketch events that occurred in my day-to-day life. Around 1980, China was just starting to open up, but we didn't have many sources of entertainment. Most people didn't have a television, and even if they did it was black and white or only had one channel and children's programs were rare. But I didn't feel I missed out on anything; we climbed trees, went walking in the hills, rode our bikes, went out into the countryside. It was in my sketchpad that I recorded my reflection on life and my impressions growing up. These were my earliest artistic efforts.

Where is your favorite place to see art?

Most people feel that you should go to a gallery to appreciate art, as you can observe the art of the great masters, but as far as I am concerned, you see art everywhere. It's in life, on the street, in your thoughts, and in the lives of other people. We need to observe more and understand more about our world, finding inspiration to allow us to reflect art in a non-artistic environment.

Describe your work in three words?

Creativity, make-believe, love.

What is your favorite color and why?

When I was young I preferred deep tones, but now I like faded colors or colder tones. I used to like yellow and green, and of course red; but never pink. This is because it was drummed into me by my mother when I was small that pink was a bit vulgar. Now I don't have any particular color that I prefer. Once you have used all the colors, there is a day when you discover that you can no longer put a finger on which color your prefer. Maybe it's a blend? Human beings are perceptive creatures, there is always a difference in what you see of the world and the color you want to use to describe that world; this is an important part of what art is!

What advice would you give to your twelve-year-old self?

I had lots of freedom as a child and was able to be myself and try the things I love. But it is not so easy for children to do this nowadays. Despite the different experiences we all have in life, we need to remain inquisitive and preserve a childlike innocence. We must remain enthusiastic about life, while allowing ourselves to do things we enjoy. Whatever happens you mustn't waste your youth!

31

Famous Art Schools

Rhode Island School of Design, USA
Founded in 1877, this was one of the first art schools established in the United States. It's considered to be one of the best in the world. Famous alumnae include Francesca Woodman, Jenny Holzer, and Kara Walker.

University of the Arts London, UK
UAL is a university in London specializing in art, design, fashion, and performing arts. It is split into six colleges—Camberwell College of Arts, Central Saint Martins, Chelsea College of Arts, London College of Communication, London College of Fashion, and Wimbledon College of Arts. Each college has different specialist subjects — there is something for everyone! Famous alumnae include Maggi Hambling, Sarah Lucas, and Gillian Wearing.

Slade School of Art, UK
Part of University College London, the Slade focuses on contemporary art and the histories and theories behind it. Famous alumnae include Gwen John, Dora Carrington, Paula Rego, Phyllida Barlow, Mona Hatoum, Tacita Dean, and Rachel Whiteread.

Royal College of Art, UK
The RCA was founded in 1837 and is different to the other art universities as it's the only entirely postgraduate art and design university in the world. Famous alumnae include Barbara Hepworth, Bridget Riley, and Tracey Emin.

Glasgow School of Art, UK

This is the only university in Scotland that offers degrees in architecture, fine art, and design. It is famous for the Mackintosh Building, which was completed over one hundred years ago. Jenny Saville is one of its most famous alumna.

Koninklijke Academie van Beeldende Kunsten, Netherlands

This royal academy was founded in 1682, making it the oldest art school in the Netherlands and one of the oldest in the world. During the 1800s, the school was running out of money and the students had to work in an old warehouse. There wasn't enough light to paint so eventually they had to move to a different location. Nowadays the school is flourishing with students from across the world.

École des Beaux-Arts, France

Established in 1648, this art school is one of the oldest in the world. It teaches its students about classical forms of art and also houses the largest public collection of art in France. In the seventeenth century, Louis XIV used graduates from the school to decorate his palace at Versailles!

Bauhaus, Germany

Although only open from 1913 to 1933, the Bauhaus in Germany was one of the most important art schools. Its courses and the students that came out of the school heavily influenced modernism in art, design, craft, and architecture. Famous alumnae include textile artist Marianne Brandt, Gunta Stölzl, and Anni Albers.

SimRyn GiLl

Born 1959

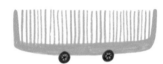

Simryn Gill makes art out of photographs, collections, and things she finds in the world around her. She is often inspired by objects that might seem insignificant on their own, but take on new meaning when she alters them and groups them together.

Gill was born in Singapore, and grew up in Malaysia where her family is from. She now lives and works in Australia and Malaysia. In her work, Gill looks closely at small details in the places where she lives, such as trees, flowers, things at the local markets, things dropped on the pavement, or washed up on the beaches.

Forking Tongues is a large spiral made of antique cutlery combined with dried red chiles. Gill laid them down in a unique pattern to create a stiking floor drawing, placing these objects in a way they would not usually be seen. The work is beautiful to look at, and has layer upon layer of possible meanings.

Gill also works a lot with books and paper—as always, taking something that is seemingly set in stone and transforming it. For a series called *Pearls* she made necklaces for friends by turning all the pages of their favorite books into extravagant beads and stringing them together. In another work called *Carbon Copy,* she took statements about outsiders and migrants from an Australian and a Malaysian politician and then mixed up the texts to highlight the words they used.

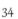

For the series *A Small Town at the Turn of the Century*, Gill photographed people going about their various daily tasks in her hometown of Port Dickson in Malaysia. They are pictured in groups and alone, inside and outside, at work or at leisure—but all have their heads replaced by local tropical fruits such as rambutans and bananas. The result is funny but also makes you wonder about lots of things, such as how humans and nature are connected, and how people can be stereotyped according to where they come from. The more you look at Gill's work, the more you discover to think about.

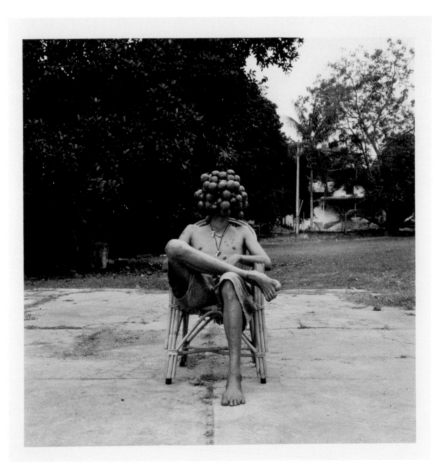

A Small Town at the Turn of the Century 1999-2000

GUERRILLA GIRLS

Founded 1985

In 1985, posters started appearing on the streets of New York, highlighting the lack of art by women in public galleries. These posters were the work of a group of anonymous feminist artists, art historians and curators who called themselves 'The Guerrilla Girls'. They are still working today, and ironically, some of their protest art is displayed by the institutions they protest about.

The Guerrilla Girls point out that women in art galleries tend to be nudes, painted by men, to be looked at by other men – rather than women artists painting what they see. They use research, statistics and humour to make a bigger point, which is that across a wide range of public and private galleries only a small percentage of the art on display is by women and people of colour. As they put it: 'the history of art is really the history of power'.

Through books, posters, stickers and videos they have also exposed a bias against female screenwriters and directors in Hollywood, and other examples of a lack of diversity in creative industries.

'You're seeing less than half the picture without the vision of women artists and artists of colour.'

These days galleries are keen to change, and many of them are making a deliberate effort to buy and show more art by women and minorities. Nevertheless, the vast majority of art in public collections in America and Europe was made and chosen by white men, and the message of the Guerrilla Girls is as relevant as it has ever been.

Why do you make art?

There are many ways to fight injustice in the world and art is one of them.

Why do you wear gorilla masks?

As a group whose members are anonymous, we needed a disguise so we could appear in public. Gorilla sounds like Guerrilla. It's crazy but it works!

What advice would you give to young activists?

Speak up for what you believe in, and use your creativity to do it. But don't worry about taking on every issue all at once. Just do one thing. If it works, do another. If it doesn't, do another anyway.

Why don't you use your real names?

Each Guerrilla Girl takes the name of a dead woman artist. This is a way to maintain our anonymity, and also a way to honour brilliant artists, many of whom were left out of art history, even if they were successful in their own time. Some of our pseudonyms: Alma Thomas, Zubeida Agha, Shigeko Kubota, Frida Kahlo and Claude Cahun.

What is your favourite art medium, and why?

We love doing street posters, which use facts, humour and outrageous visuals. We sneak around in the middle of the night putting them up in cities all over the world, and these days they are exhibited in lots of museums as well.

The Advantages of Being a Woman Artist
1988

THE ADVANTAGES OF BEING A WOMAN ARTIST:

Working without the pressure of success
Not having to be in shows with men
Having an escape from the art world in your 4 free-lance jobs
Knowing your career might pick up after you're eighty
Being reassured that whatever kind of art you make it will be labeled feminine
Not being stuck in a tenured teaching position
Seeing your ideas live on in the work of others
Having the opportunity to choose between career and motherhood
Not having to choke on those big cigars or paint in Italian suits
Having more time to work when your mate dumps you for someone younger
Being included in revised versions of art history
Not having to undergo the embarrassment of being called a genius
Getting your picture in the art magazines wearing a gorilla suit

A PUBLIC SERVICE MESSAGE FROM **GUERRILLA GIRLS** CONSCIENCE OF THE ART WORLD

Natalia Goncharova

1881 - 1962

In Moscow in 1913, one young rebel artist set the trend. She was so popular that when she painted her face with flowers, all the young bohemians and aristocrats copied her. Her name was Natalia Goncharova. Before the First World War she led the Russian avant-garde and cofounded three groups of artists that would help change the course of modern art.

Born in rural Russia, but drawn to study art in Moscow, Goncharova loved to defy the authorities. She appeared topless in public, cross-dressed, and was arrested for painting nudes. Contempoary French artists such as Paul Gauguin and Henri Matisse were an influence, but Goncharova always tried to find a "Russian" way of making art.

As a working woman herself, she often painted women at work—in the fields, making lace, or selling fruit. She liked modern inventions and, with her partner Mikhail Larionov, she created a new style called "rayonism" to capture movement. Goncharova was also inspired by the colors and themes of Russian folk art. Many rich Russians saw peasant art as "primitive," but she believed that it was important and interesting.

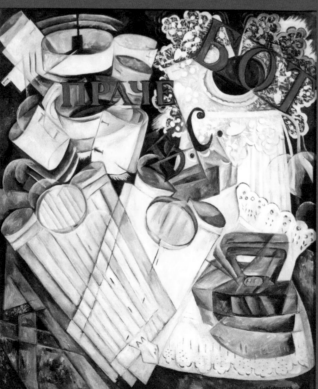

Linen 1913

In 1913, Goncharova held a one-woman show displaying nearly eight hundred paintings, and she made the set and striking costume designs for a new ballet by Sergei Diaghilev called *Le Coq d'Or*. The next year she left for Paris to see the first performance of the ballet. It was an international success, and she went on tour with the company.

After the Revolution in 1917 the Russian state was not friendly toward experimental artists and Goncharova decided to settle in France. In addition to working on ballets, she continued to paint and illustrate. Her bold, rhythmic designs for a fashion house called Myrbor were highly prized. She was friends with Pablo Picasso, Fernand Léger, and Marc Chagall. There was no stopping her!

But Paris was ravaged by the Second World War. Goncharova lost her money and spent time caring for Larionov. She was impoverished and her work was neglected until shortly before her death.

In 2007, nearly a hundred years after her first big show, thanks to wealthy new Russian collectors and an increasing fascination with Russian art, Goncharova's paintings began to sell for millions. The art world rediscovered her brilliance. She has found her place again as one of the great trendsetters in modern art.

Two Russian Maidens 1920

WOMEN IN THE PICTURE

Since the beginning of time, women have been the subject of great art. But who were these people the artists loved to admire?

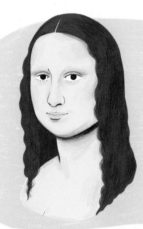

Lisa Gherardini (1479–1542)

Lisa Gherardini lived in Renaissance Italy. She was married to a wealthy merchant and had five children. You might not know her by her full name, but you probably know her nickname: Mona Lisa! Sadly, we don't know much about her inner life—including what she was thinking about while Leonardo da Vinci painted her in 1503.

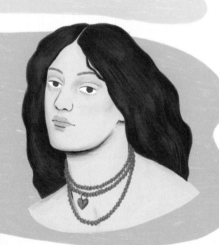

Elizabeth Siddal (1829–1862)

Elizabeth Siddal was a famous Pre-Raphaelite "stunner." At age nineteen, she posed for John Everett Millais's painting of Ophelia in 1851. For this, she lay fully dressed in a bath of water and caught a terrible cold. Siddal was an artist and poet in her own right. She died at the age of thirty-two of a laudanum overdose.

Marie-Thérèse Walter (1909–1977)

Marie-Thérèse Walter met Picasso when she was seventeen. A happy, athletic young woman, she inspired many of his great paintings and sculptures during the 1930s. After he died in 1973, she sold two of his paintings to pay medical bills for his gravely ill grandson. A sculpture that Picasso made of Walter is on his grave.

Patti Smith *(Born 1946)*

Patti Smith was a roommate, lover, and muse of the photographer Robert Mapplethorpe in New York in the late 1960s. She is a singer-songwriter and performance artist whose groundbreaking album *Horses* inspired many punk rock bands. Smith continues to be an inspiring musician and poet with fans worldwide.

Sue Tilley *(Born 1957)*

Sue Tilley was part of the lively London club scene of the 1980s and Lucian Freud's favorite muse in the 1990s. She is the subject of his famous nude portrait, *Benefits Supervisor Sleeping*. She loved the experience of working with Freud, who referred to her as "Big Sue."

Lily Cole *(Born 1987)*

Lily Cole is the subject of six portraits at the National Portrait Gallery. From the age of fourteen she had a successful international modeling career. She then moved into acting, featuring in various films. Cole has a degree in the History of Art from Cambridge University and is now involved with several charities and runs an app designed to encourage kindness.

You might notice that while some go on to great things, not all muses' lives end happily. But what is clear is that they were all far more than just the woman in the picture!

ANtHEA HAmilTON

Born 1978

What do 1970s disco, Egyptian hieroglyphics, and Japanese kabuki theater have in common? They're all featured in the work of Anthea Hamilton. She mixes up a wide range of influences with fun references to everyday modern culture. The results are thoughtful, eye-catching, and surprising.

Hamilton was born in London, where she lives and works. She uses video, sculpture, sewing—whatever she likes, in fact—to express herself. She likes to create theatrical environments. Her installations are often big enough to walk around, and sometimes performers do exactly that—such as in *The Squash* at Tate Britain in 2018, where they interacted with visitors.

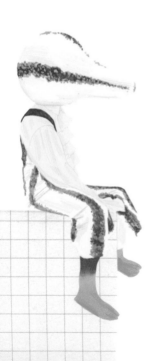

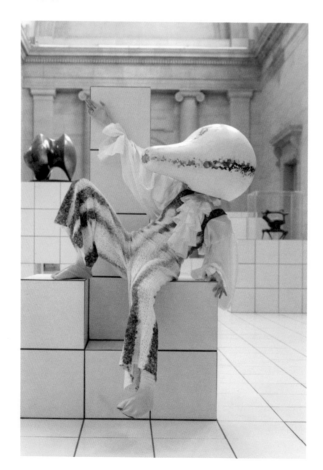

The Squash 2018

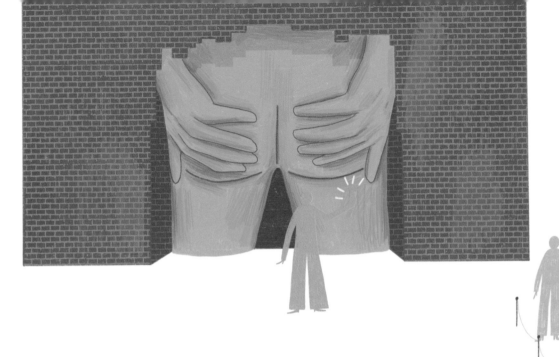

For *Project for Door (After Gaetano Pesce)*, she was inspired by an Italian architect called Gaetano Pesce and his plans for a doorway of a New York skyscraper that was never made. It stands 18 feet high and consists of a pair of hands holding a vast, bare bottom. Unlike the original plan, you can't walk through this sculpture, but it's designed to make you smile, and when it was on display in New York and London people lined up to take a selfie in front of it.

Hamilton's art is not just about selfies, though. Her pieces can look surreal—as if they were inspired by a dream—but she puts a huge amount of research into each detail in order to create the physical reaction she wants you to have. It might be a grin or a gasp of surprise, but in some way it will connect you with how she sees the world.

Along with other leading British artists such as Tracey Emin, Bridget Riley, and Rachel Whiteread, she designed one of the twelve posters for the 2012 Olympic Games. Called *Divers*, it was typical of her humorous style, consisting of the Olympic rings and a silhouette of upside-down female legs superimposed on a swimming pool.

BARBARA HEPWORTH

1903 - 1975

Barbara Hepworth is one of the greatest sculptors of the twentieth century. Her sinuous forms are often drawn from nature, and also examine the place of people within it. She inspired a generation of artists, designers, and architects.

Hepworth grew up in Yorkshire, in the north of England, and studied sculpture at the Leeds School of Art. She loved the beautiful natural landscape of her home county, and the contrast with the man-made industrial towns that sprang out of it.

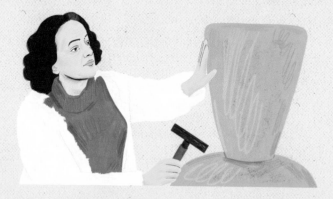

In the 1920s and 1930s she traveled around Europe, getting to know some of the great artists of the day, including Pablo Picasso and Piet Mondrian. She saw inside their studios and earned their respect as a sculptor herself.

Hepworth was interested in the curves of the human form and nature, reducing them to convex and concave tactile shapes. In *Pelagos* she used wood and strings to capture the feeling of watching waves and rolling hills. She loved working with natural materials, carving her ideas directly into wood and stone.

"I rarely draw what I see.
I draw what I feel in my body."

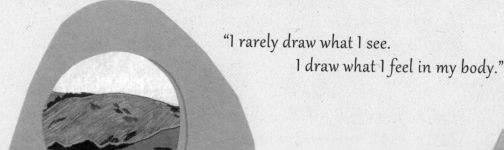

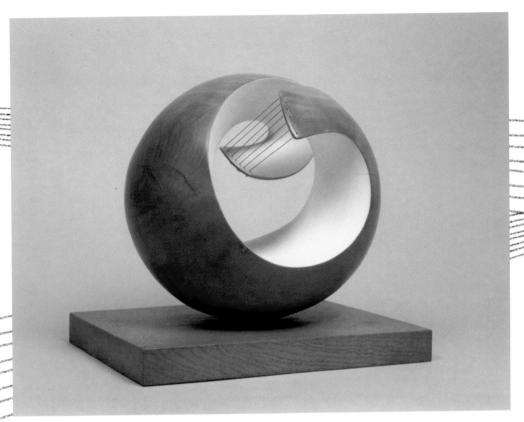

Pelagos 1946

Hepworth was also fascinated by the idea of negative space—an awareness of the air in between and around objects. This led her to develop a style of "piercing" that involved carving holes into her pieces. Henry Moore, also from Yorkshire, is famous for this style, too, though Hepworth did it first. She liked her sculptures to be placed in the landscape so that you could look through the holes and see the work's relationship with the view beyond.

At the beginning of the Second World War, Hepworth and her husband, the painter Ben Nicholson, moved to St. Ives in Cornwall. She set up her studio overlooking the garden and made sculpture there for the rest of her life. Today, you can visit her house and look through the windows of her studio, which is still full of her many tools and some of the pieces she was working on when she died. It is possible to imagine that she has just stepped out and will be back soon to carry on where she left off.

LuBaiNa HiMid

Born 1954

Who were the enslaved people and migrants who left Africa in past centuries? What were their names; what did they think and feel? Lubaina Himid is fascinated by these questions and makes us aware of them with her playful use of paint and everyday objects.

Himid was born in Zanzibar, Tanzania, and came to the United Kingdom as a child. When she was starting out as an artist, she noticed that black people were not represented in the media or the arts. She became a member of the black arts movement of the 1980s, making paintings, wooden cutouts, and installations that explored black identity.

At art school, she studied theater design, and there is a theatricality to the installations and projects she creates. Sometimes, her wooden cutouts come off the gallery wall and stand on the floor, creating people from history who seem to walk among us.

In 2017, Himid made history by becoming the first black woman, and the oldest artist, to receive the prestigious Turner Prize for contemporary art.

Did you always know you wanted to be an artist?

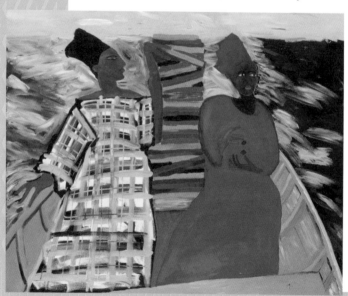

My mother was a textile designer and so, because we looked at beautiful things in shops and in art museums when I was a child, the idea of being an artist was always a possibility in my mind.

Between the Two my
Heart is Balanced 1991

What was your favorite subject at school?

My favorite subject at school was English. I loved reading, talking, and writing poetry, and my teacher was clever and encouraging.

How do you go about making an artwork?

I think a lot about impossible tasks and depicting difficult subjects or events. I make scruffy drawings on envelopes and scraps of paper. I experiment to find the right surface upon which to paint, this could be anything from wooden furniture to plates or canvas and paper. I read poetry and essays and look at picture books. Sometimes I talk to other artists about what I'm trying to do. Then I start to work (almost always listening to music) but continually thinking, drawing, looking at books, and talking all through the process.

What inspires you in your life?

People's resilience and their determination to make the world a better place.

Where is your favorite place to see art?

It's exciting to see art in the artist's studio and good to see it in people's living and working spaces. However art galleries, when they are free, can be the most exciting places to really look long and hard at what the artist has achieved. I'm fond of Tate Britain because that's where I went as a child and began to understand the way that painting could transform my life. I love the Serpentine Gallery because of its potential to be a place in which people can have a chance encounter with art as they stroll in the park.

What advice would you give to young artists?

Being an artist is about working incredibly hard every day, and at the same time feeling free to do as you please with the ideas you develop and the materials you have.

FRAMING THE PICTURE

CRITICS AND CURATORS

Women have been creating art for as long as men, so why are so few of them celebrated? Now, with more women writing and talking about the art world, a new understanding of what art history means is underway.

Linda Nochlin

(1931–2017) was an American art historian. In 1971, she wrote a famous essay called "Why Have There Been No Great Women Artists?" which described the many ways women had been prevented from making art, and excluded from art history when they did.

Lucy Lippard

(born 1937) is an art critic, writer, and curator who started off working in the library of the Museum of Modern Art in New York. She curated the exhibition *Eccentric Abstraction* in 1966, which brought Louise Bourgeois to the art world's attention.

Thelma Golden

(born 1965) is director and chief curator of the Studio Museum in Harlem, which is the world's leading institution devoted to art by artists of African descent. In 2018 she was awarded the J. Paul Getty Medal for her extraordinary contributions to the art world.

Laura Mulvey

(born 1941) coined the phrase "the male gaze" to describe how women are often depicted in Hollywood films, as if they are there to be looked at by men. Mulvey is a British film theorist and the idea came from an essay she wrote in 1973. She meant it to be provocative and it was. It started decades of debate relating to both film and art.

Roberta Smith

(born 1957) is the *New York Times* cochief art critic, seeing over twenty art shows a week. In a career spanning over thirty years she has written thousands of pieces to challenge and explain the latest trends in contemporary art.

Rosalind Krauss

(born 1941) is an art critic, theorist, and professor in New York City. She founded *October* magazine which transformed the way people understood art by publishing political and feminist essays on modern art.

Gwen John

1876 - 1939

To look at the muted tones and inner stillness of her paintings, you might think Gwen John had a quiet life. In fact, she was daring, independent, and passionate about love and art. Her beloved younger brother, Augustus—also an artist and well known for his brilliant drawing style—overshadowed her during their lifetimes, but Gwen has since become the more celebrated.

John was a lawyer's daughter, born in a seaside town in Wales. In 1895 she joined Augustus at the Slade School of Fine Art in London. After living in a run-down London squat, John and a fellow artist called Dorelia McNeill decided to walk to Rome, selling paintings along the way. This was not normal behaviour for young women in 1903!

"I don't live calmly like you and the rest of the world."

In fact, they ended up in Paris, where John began modeling for the sculptor Auguste Rodin. She fell madly in love with him and moved to Meudon, a suburb of Paris, to be closer to him. They had a long relationship, but Rodin did not return John's passion. She considered giving up painting, but her brother introduced her to a major American collector called John Quinn, who encouraged her to continue with her work.

John's paintings portray the opposite of her precarious adventures. Their similar tones suggest calmness, intimacy, and reflection. Leading a solitary existence, she painted mostly interiors and portraits of women. Her sitters look thoughtful, as though they have a deep interior life. John doesn't make them look idealized and beautiful, but intelligent and interesting. Often, she would create many different versions of a painting until she felt she got it right.

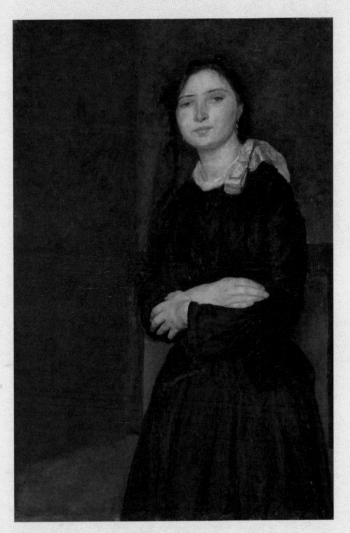

Dorelia in a Black Dress 1903-4

Later on she was unlucky in love again, this time with a woman called Vera Oumancoff. John showered her with letters, enclosing hundreds of drawings and watercolors. Unmoved, Vera stuck them in a cupboard. John's final days were spent in Meudon, in a house on stilts set in an overgrown garden, surrounded by cats she fed with expensive pâté. She set off for Dieppe one day in 1939, and died there, at age sixty-three. Independent to the end!

John's letters to Vera were discovered decades later, still in the cupboard. They helped inspire a major biography, published over forty years after she died. Now art lovers all over the world appreciate her impressive artworks.

JOAN JONAS

Born 1936

In 1970, a sculptor called Joan Jonas traveled from New York to Japan. There, she discovered fourteenth-century Noh theater and bought a brand new piece of technology: a Sony Portapak video camera. She was about to become a pioneer: the first person to use live video in her artistic work.

Jonas grew up immersed in the New York art scene. Her family took her to galleries and the opera, introducing her to poetry, jazz, and magic shows. When she discovered performance art she found her path. She destroyed all her sculptures and set out to create her own multimedia form of art.

Using props—and with the occasional help of dancers and musicians—Jonas creates performance pieces for her audiences. She incorporates poetry, masks, live painting, costume—and even her dog, Ozu.

Jonas is interested in landscape and mythology. In *The Juniper Tree*, taken from the Grimm's fairy tale, she explored how stories are told through repetition, repeatedly painting the head of the boy who is killed by his wicked stepmother. A lot of her work is about how women are seen, and how they see themselves. She has often used mirrors, as in her solo piece, *Mirror Check*, where she inspected every part of her naked body with a hand mirror.

She does not expect people to understand her vision straight away, but asks you to take time to experience a piece, and perhaps even view it several times. In her eighties, she still travels the world to feed her curiosity and to keep making art.

The Juniper Tree 1976, reconstructed 1994

What inspires you in your life?

Reading a book. Listening to music. Looking at paintings. Sculpture. Film and video.
Walking along the river, in the forest, and swimming in the sea, the river, and the lake.

What was your favorite subject at school?

Art (art history and the practice of painting, sculpture, and drawing).

What is your favorite medium, and why?

I don't have a favorite, I use many types of media in my work.

If you weren't an artist, what would you be?

A scientist, or a poet musician.

What advice would you give to young artists today?

Love what you do. Work hard and share with your peers!

If you could only save three artworks in the world, which would they be?

The paintings of Kerry James Marshall, Angkor Wat in Cambodia, and the city of Venice.

FRidA KAHLO

1907 - 1954

Growing up in Mexico, Frida Kahlo was a strong-willed young woman who posed for photographs in her father's clothes and was passionate about politics. She originally wanted to be a doctor, but became a painter whose life was as inspirational as her art. Fellow artist André Breton described her painting as "a ribbon around a bomb."

At eighteen, Kahlo was in a bus crash and nearly died when a handrail pierced her body. She lay covered in blood and gold dust spilt from a pouch carried by a fellow passenger. Afterward, she lived in constant pain, but Frida did not let tragedy define her: she always defined herself.

Mexico was Kahlo's greatest love. She often gave her birth date as 1910—the date of the Mexican Revolution. She loved the country's traditions, its ancient artifacts, and its colorful, embroidered costumes. These she adopted and adapted to create her identity. Unable to become a doctor, she turned to art. She decorated her surgical corsets, and painted self-portraits even while forced to lie flat, using a special easel and mirror set up above her bed. She married Diego Rivera, Mexico's most famous painter, and turned her family home, the Blue House, into an artistic hub.

Kahlo painted what was around her: the fruit and flowers of her lush courtyard garden, the animals she loved, but mostly herself. She made the most of what was unconventional about her looks, emphasising her dark unibrow and defiant gaze to make them a signature feature.

Her paintings, often made as gifts, have a dream-like quality. They draw on Mexican traditions, politics, and the pain caused by disability and infidelity. She doesn't seek to hide the hurt, but paints herself as both suffering and triumphant.

When Kahlo died in 1954, at age forty-seven, she was not widely known outside the art world. But a biography by Hayden Herrera in 1983, a film starring Salma Hayek, and having Madonna as a fan all helped to make her famous. Now over two thousand people a day go to visit the Blue House in Mexico City and pay their respects to her.

To be like Frida Kahlo is not to copy her. Kahlo didn't copy anybody. She would have wanted her fans to be resilient, to be inspired by what they love and to always be themselves.

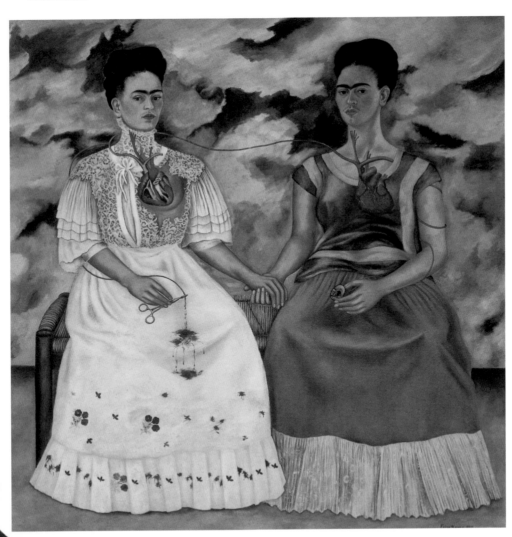

The Two Fridas 1939

MUSEUMS AROUND THE WORLD

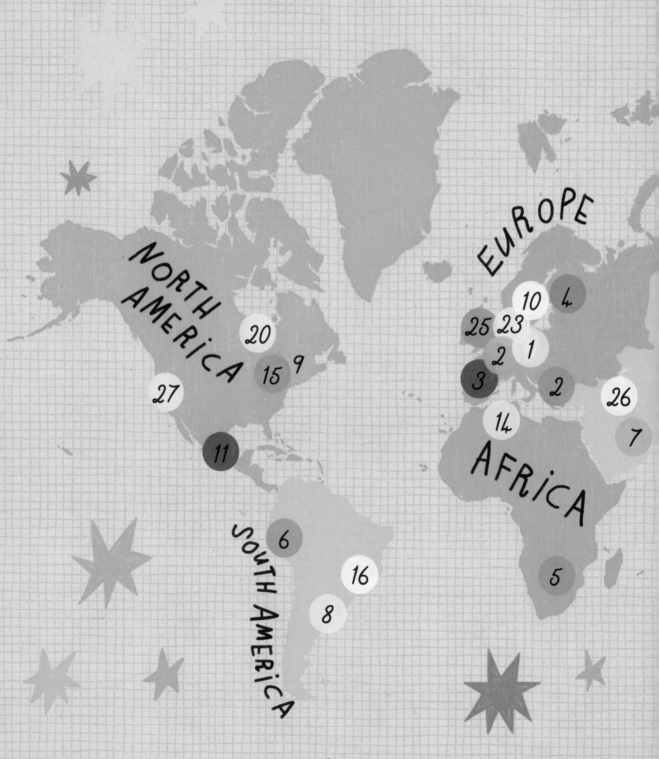

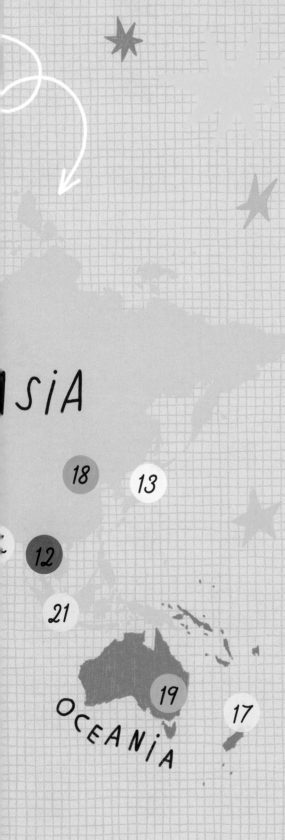

1. Museum Brandhorst (Munich)
2. Centre Pompidou (Paris)
3. Museo Guggenheim Bilbao
4. State Hermitage Museum (St. Petersburg)
5. Johannesburg Art Gallery
6. MALI—Musée d'Art de Lima
7. Louvre Abu Dhabi
8. MALBA—Museo de Arte Latinamericano de Buenos Aires
9. Metropolitan Museum of Art (New York)
10. Moderna Museet (Stockholm)
11. Museo Nacional de Arte (Mexico City)
12. MOCA—Museum of Contemporary Art—Bangkok
13. Museum of Contemporary Art Tokyo
14. Musée National des Beaux-Arts (Algiers)
15. Museum of Modern Art (New York)
16. MAM—Musee de Arte Moderna (Rio de Janeiro)
17. Museum of New Zealand Te Papa Tongarewa (Wellington)
18. National Art Museum of China (Beijing)
19. National Gallery of Australia (Canberra)
20. National Gallery of Canada (Ottawa)
21. Galeri Nasional Indonesia (Jakarta)
22. National Museum of Contemporary Art, Athens
23. Rijksmuseum (Amsterdam)
24. Salar Jung Museum (Hyderabad)
25. Tate Britain and Tate Modern (London) and Tate Liverpool and Tate St. Ives
26. TMOCA—Tehran Museum of Contemporary Art
27. MOCA—Museum of Contemporary Art (Los Angeles)

Yayoi Kusama

Born 1929

Yayoi Kusama has been called "the princess of polka dots." In 2014, her exhibitions were attended by more people than those of any other artist in the world. Perhaps you have seen her sculptures of dotty pumpkins or her "infinity" rooms made of mirrors and lights?

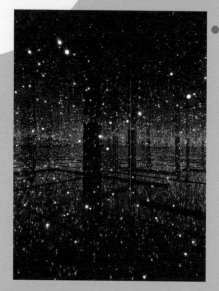

Kusama's works are alive with color and, as one of her works is titled, *Filled with the Brilliance of Life*. Yayoi sees the world differently from most people and has lived with mental illness since childhood. As a girl she had obsessive thoughts and hallucinations where dots on a tablecloth would seem to multiply until they were all around her. This gave her a sense of disappearing into the infinite universe. Instead of holding her back, it has been the inspiration for all her life.

Filled with the Brillance of Life 2011

"I fight pain, anxiety, and fear every day, and the only method I have found that relieves my illness is to keep creating art."

In the 1960s, Yayoi went to New York, where her avant-garde work influenced pop artists such as Andy Warhol and Roy Lichtenstein (another fan of dots). She constantly experimented with new materials and new technologies to create paintings, sculptures, installations, and performance art.

Today, Kusama lives and works in Tokyo, making a splash with her bright red hair and dot-covered clothes. Her art, born out of panic and anxiety, is perhaps so popular because it is suffused with wonder, love, and joy.

Did you always know you wanted to be an artist?

Yes, I have been painting and making sculptures for as long as I can remember.

Who was your role model growing up?

When I was young there were certain painters whose work I admired. But my greatest role model has been the natural world, and I have always relied on my own vision for inspiration.

What inspires you to make your art?

My love for the world has always been the driving force and energy behind all that I do.

Why do you think making art is important?

I am compelled to produce works constantly to express my thoughts and feelings. Even in the middle of the night, if an idea comes to me, I grab my sketchbook and draw. Art is my way of making sense of the world.

What is your favorite medium, and why?

I love working with all types of materials. For me the medium is less important than the process. I work with anything that allows me to express my vision.

What are your three top tips for becoming an artist?

Tell your truth. Enjoy the process. Make art for always.

Agnes Martin

1912 - 2004

A large, white square painted with pale peach stripes. Look closer and you'll see the pencil marks the artist used to draw the lines, fading toward each edge. It's one of the delicate works of Agnes Martin—mesmerising and beautiful.

Martin was born into a strict, religious family on a farm on the Canadian prairie—a place "so flat you could see the curves of the earth." She always worked hard. At school she was such a good swimmer she nearly qualified for the Olympic team.

It took Martin many years to find her path. She trained as a teacher in New York and New Mexico, and did a range of jobs—even dishwashing when she was short of cash. Finally, at the age of thirty, she decided to become an artist. Martin wanted to recreate the feeling of joy that nature's beauty inspired in her, but it took years to get it right.

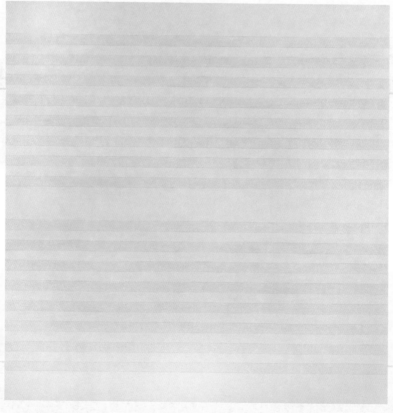

I Love the Whole World 1999

"These paintings are about freedom from the cares of this world."

Settling in New York, Martin eventually found her style at age forty-six: the abstract "grid." Starting with a 20 square foot canvas—"a size you can walk into"—the grid combined a regular pattern of small rectangles, usually drawn in pencil on a pale base color, with the painstaking application of another pale color on top. The result was an image that seemed repetitive and perfect, but on close inspection was full of little bumps and smudges. The imperfections remind you that a human hand created them. Their subtle beauty was a huge success. Martin, however, was always strict about judging her work and threw out more canvases than she kept.

Martin experienced mental illness and worried about her growing fame. After ten years she gave up, selling all her possessions and traveling around America in a pickup truck. In the 1970s, she moved back to New Mexico and lived alone, in a house she built herself, without TV or radio. After seven years she started making art again and kept working until her death at age ninety-two. As she got older her paintings got smaller to make them easier to handle. As popular as ever, they continue to make people happy, the way she wanted them to.

ANA MENDIETA

1948 - 1985

How can a person turn into art? Ana Mendieta explored many different ways of using her body to express her energy, her experience as a woman, and her connection with the natural world. She said that women artists were not usually appreciated until they are old, so she wanted to live a long life in order to enjoy recognition when it came. Sadly she died at thirty-six, just as she was starting to become famous.

Mendieta was born in Cuba and lived there until she was twelve, when her father sent her and her sister to the United States. He was later held as a political prisoner for many years. His daughters were looked after in a strict orphanage and a series of foster homes in Iowa, which were very different from their old vibrant family life at home.

"My art is the way I re-establish the bonds that unite me to the universe."

At university, Mendieta joined the "Intermedia Program," studying a mix of performance, film, and photography. Inspired, she made a lot of her work while she was still at university. A few of her artworks were reactions to the injustices and crimes against women that she saw around her. She also began her *Silueta* (silhouettes) series, a type of land art, in which she created impressions of her body in the mud, sand, or stone of natural landscapes, filled the impressions in various ways, and documented the results in photographs and videos.

Mendieta often used natural materials, such as feathers, blood, and hair. In one series of photographs, she captured one of her friends trimming his beard hair, which she then placed on her own face. Does the mustache make her look like a man? Mendieta often challenged gender stereotypes: asking why we expect people to look a certain way.

Mendieta moved to New York in 1978, where she made friends with leading feminists. She won grants for her work that allowed her to travel back to Cuba and to Rome, a city she loved.

Though she did not live to see the fame she deserved, Mendieta has become an inspiration for artists, feminists, and exiles. Her *silueta* is still there in the history of modern art.

Untitled (Facial Hair Transplant) 1972

Did you Know?

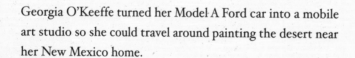

Paula Rego's London studio is an old stretcher factory.

Lorna Simpson has two studios in Brooklyn, designed to suit her flexible working process for photography, video, and canvas.

Some of Bridget Riley's works are so big she makes them with the help of a team of assistants—just as artists did in the days of the Renaissance.

Georgia O'Keeffe turned her Model A Ford car into a mobile art studio so she could travel around painting the desert near her New Mexico home.

Agnes Martin had very few extravagances in her life, but one was the spotless white BMW she used to drive to her studio in her eighties.

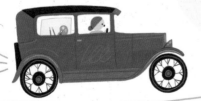

Gwen John developed her own technique of mixing chalk and plaster with oil paint. This is what gives her paintings their unique, delicate, fragile layers.

Frida Kahlo used old perfume bottles to keep nail varnish remover and tequila in (but not at the same time).

Lubaina Himid has used jelly molds and the insides of drawers as surfaces for her paintings.

Joan Jonas invented her own art medium, called My New Theater, to display her work in miniature.

One of Rachel Whiteread's first sculptures was a plaster cast of the inside of a cupboard, covered in black felt. Art can be made out of anything!

One of Claude Cahun's favorite activities was to put her cat on a leash, blindfold herself, and then go for a walk with the cat guiding her around.

Berthe Morisot

1841 - 1895

In 1876, a breakaway group of French artists held their second exhibition in Paris. They included Claude Monet, Edgar Degas, Camille Pissarro, and Pierre-Auguste Renoir. When the art critic of *Le Figaro* newspaper went to see it, he called them:

"five or six lunatics deranged by ambition—one of them a woman."

The female "lunatic" was Berthe Morisot. Along with her friends, she was creating a new school of art, which would become known as impressionism.

Though Morisot's name is not always mentioned, she was a leading member of the impressionists from the start. She was born into a wealthy family and discovered as a major artistic talent at age nine. As a woman, she was denied formal training. She had private tutors and exhibited at the prestigious Salon de Paris at just twenty-three years old. She was the most famous artist in the group when they first exhibited in 1874.

"I do not think any man would ever treat a woman as his equal, and it is all I ask because I know my worth."

Like Édouard Manet and Auguste Renoir, Morisot was interested in painting daily life and experimenting with how to capture fleeting moments. Respectable women could not roam the streets or visit the bars and nightclubs often depicted by the men. Instead, Morisot painted the domestic scenes the men couldn't know, such as a mother alone with her children or a woman putting up her hair.

Morisot developed her own style, using rough, sparing brushstrokes to give her work an unfinished quality. She kept experimenting with new techniques, sketching a lot beforehand so she could get the effect she wanted with little paint. By 1877 *Le Temps* newspaper described her as the "one real Impressionist in this group."

Morisot's sister Edma was talented, too, but gave up painting to get married. Berthe did not envy her. Do the women with their children so beautifully captured by her brush look just a little wistful? Nevertheless, at age thirty-three, Morisot married Eugène Manet, the brother of Édouard. Eugène gave up his artistic career to manage hers. They had a daughter, Julie, whom Morisot adored and painted many times.

Morisot died at fifty-four, after nursing Julie through an illness. However, she left behind hundreds of paintings and watercolors to celebrate her busy and successful life.

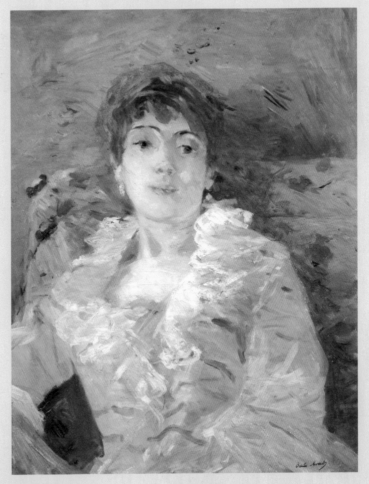

Girl on a Divan 1885

Georgia O'Keeffe

1887 - 1986

Georgia O'Keeffe is one of the twentieth century's best-loved painters. From an early age, she dedicated herself to art. She dressed almost entirely in black and white, so she wouldn't "waste time" choosing her clothes each day. She was popular, but even at school she stood out.

O'Keeffe was top of her year at art school in Chicago, but she was not truly happy making art until she did a summer course in 1912 based on the ideas of an artist called Arthur Wesley Dow. His theory of art was to "fill a space in a beautiful way," simplifying shapes and concentrating on the arrangement of colors. At last, at age twenty-five, O'Keeffe could paint what she *felt*, as well as what she saw.

There is something very feminine about her famous paintings of flowers. What is revolutionary about her work, however, is how close-up she paints them, so they seem to become almost abstract. With their warm or cool colors and overwhelming size, they are designed to make you pause and think, so that they become "your world for the moment," as they did for her.

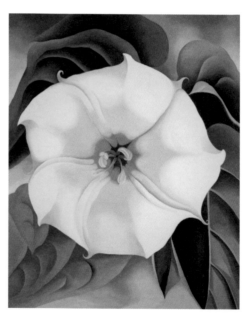

Jimson Weed/White Flower No.1 1932

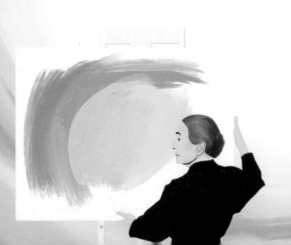

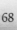

Later, O'Keeffe painted the dry bones and vast, desert landscapes of her chosen home in New Mexico. Although she moved far away from the American art scene in New York, her trailblazing canvases and remarkable use of color made her successful quite quickly, and in 1946 she became the first female artist to have a retrospective exhibition at the Museum of Modern Art in New York.

Though she went blind in her later years she still made art with the help of assistants. O'Keeffe was a force of nature! She inspired and supported many other women artists. But she did not want to be known as a "woman artist." In 1943, she said:

"Men put me down as 'the best woman painter.' I think I'm one of the best painters."

Behind The Scenes

Want to work in the art world, but not sure where to start? Here's a handy guide to some of the key roles at museums and galleries.

Curatorial

The curators are the heart of any museum. They are experts on artists, artworks, and choose what to display on the walls. They are responsible for creating exhibitions and buying new pieces for the collection.

Visitor services

Greeting visitors and showing them where to go and what to see is arguably one of the most important roles in a museum. Visitor services make sure that the experience of the people stepping through the doors is enjoyable from beginning to end.

Interpretation

Sometimes art can be complicated and a little tricky to understand, but the interpretation team is on hand to explain the ins and outs of every artwork on display.

Conservation

Taking care of artworks is essential for any museum. This task falls to the conservation team, who specialize in repairing and restoring all types of artworks, from paintings to film.

Community outreach and education

The education teams work closely with schools, universities, and community and youth groups to teach them all about artists and the processes of making art. They often have a program of fun and engaging activities for everyone to enjoy.

Social media and publicity

There is no point in having great artwork on the walls if no one knows that they are there. Spreading the word is the main aim of the social media and publicity team. Through the museum's website, press releases, social media, and advertising they bring in audiences from far and wide.

Research and archive

What if you can't make it to the museum, but you want to know more? The research and archive team hold all the information you could ever want to know about the museum and its collection.

Human resources

Getting a good team of people working in a gallery is crucial. The human resources (HR) team scours the country looking for talented and passionate art lovers to work in all the different departments listed here.

Legal

Protecting copyrights, drawing up agreements, and working with artists' estates is the role of the museum's lawyers and legal team.

Finance and operations

Even museums have to pay their utility bills. Finance and operations take care of the buildings and grounds that are home to the artworks. They are responsible for repairing and maintaining the facilities for all the staff and visitors.

Fundraising

Money matters! The development team helps secure funding, membership, and sponsorship to make sure that the museum can continue its work and remain open to the general public.

Retail

No museum visit is complete without a trip to the gift shop and café! The commercial teams are in charge of retail, catering, publishing, licensing, and lots more.

PAULA REGO

Born 1935

Rego is a Portuguese artist, living in London. In the 1970s, she was part of an influential group that also included David Hockney and Lucian Freud. She uses pastel, acrylic, or collage to create dark stories, based on folk tales, books, and frightening childhood memories. Look out for the girls, who can be obedient or violent but are rarely shy. With a nightmarish quality, Rego's prints and paintings are intriguing and mysterious.

Why did you become an artist?

I always liked to make drawings. I started drawing when I was four, and I spent hours in my bedroom with crayons and paper drawing on the floor. I always made a low droning noise when I drew. I was an only child so I spent a lot of time alone, but my parents always knew I was OK when they heard the noise. I made drawings for them. When they went out in the evening they'd come home to find a drawing on their pillow. At school I was good at English, history, and jumping, but I was best at pictures. I was terrible at geography, still am. Making pictures is what I like best. My school let me paint murals in the hall at the end of term. During the war, my mother used to knit for the soldiers, and they'd hold fêtes to raise money, and I'd decorate the wall behind her stand with huge pictures. She liked that. She'd been to art school. And I liked the big bare wall, which I could fill with anything I liked.

Does your artwork have a meaning behind it?

Well, it has stories. I like to work from a story, and as I work the story evolves and changes all the time. Until it is finished I never know what it is going to be. I choose stories that mean something to me and then I discover my own story in them. I find out what it is by doing it. So I guess they have a different meaning by the end.

Who is your inspiration?

The picture books my father showed me were inspiring. They were scary, like Dante's *Inferno* illustrated by Gustave Doré. I also like the operas he told me about and played on Sunday mornings: *Carmen* and *Rigoletto*. He saw *Rigoletto* thirty-two times. He liked Botticelli, but I like more gruesome stuff. Really gruesome stuff! Horrible things happening. I love comic books because they are easy to read and full of disasters. I had inspiring school teachers. Art teachers who encouraged me and gave me walls to paint on.

What is your favorite color, and why?

Green, because it's a lucky color. Not because it reminds me of nature.

If you could only save one artwork in the world, what would it be, and why?

Picasso's *Guernica*, because it's a marvelous thing and very violent. I like violent work.

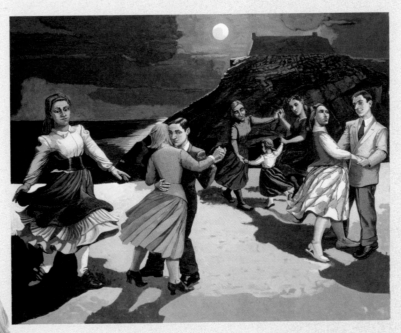

The Dance 1988

BRidJEt RiLEY

Born 1931

Bridget Riley can make painted lines move in front of you. Stare for a while at one of her canvases and you'll see. She is fascinated by how we look at flat spaces, and how our minds interpret what we see.

As a child growing up in Cornwall in the United Kingdom, Riley was intrigued by light and the way the sun created reflections on the water.

"On a fine day all was bespattered with the glitter of bright sunlight . . . It was as if one was swimming through a diamond."

She wanted her paintings to have the same "visual energy," but art school did not teach her how to create it. After traveling in Italy, and examining the techniques of old masters and post-impressionists, she developed her own new way of making art: one that seemed to undulate and ripple for itself.

At first Riley only painted in black and white, using repeated lines and curves to create rhythm and movement. In 1965, the Museum of Modern Art in New York included these early works in an exhibition of optical art ("op art") called *The Responsive Eye*.

She was horrified when she saw fashionable dresses in New York shop windows based on her paintings. Riley was not interested in being famous, just dedicated to developing the techniques behind her work. After a visit to Egypt in 1979 she started to include a range of vibrant colors, from vivid reds and oranges to purples, greens, and blues. Using simple stripes, and later diagonals and curves, she explored how the colors worked when they were placed next to each other. Once again, her canvases zinged with life.

Today, in her eighties, Riley still makes art. For an exhibition in 2010 some of her larger works were painted directly onto the walls of the National Gallery in London. Although she is quite private about her work, she remains one of the art world's reluctant celebrities.

"The music of color, that's what I want."

Nataraja 1993

DORIS SALCEDO

Born 1958

In the vast Turbine Hall of Tate Modern, a long, dark scar runs along the floor. It is all that remains of an extended crack that was made in the concrete: a work by Doris Salcedo called *Shibboleth*. Like a rift made by an earthquake, it was designed to be a simple, stark reminder of the impact of grief and loss.

Shibboleth 2007

Salcedo grew up in Colombia and studied fine art and art history in Bogotá, the Colombian capital, where she lives today. During her lifetime it is estimated that ongoing conflicts between the government, revolutionaries, paramilitaries, and crime syndicates have caused the deaths of over two hundred thousand people in Colombia. This has had a huge effect on Salcedo's art, and she often chooses to talk about those who have lost their lives to violence—whether politically motivated or related to gang struggles. She creates pieces that use everyday objects in unexpected ways to represent the grief of their friends and families.

She has made installations out of rusty needles, tables, chairs, and children's clothes. They might be sewn with human hairs, seeded with grass, or encased in concrete. Strange and unsettling, they are a reminder of lives that too often are forgotten. In a piece called *Noviembre 6 y 7* more than a hundred chairs were slowly lowered from the roof of the Palace of Justice in Bogotá to commemorate a massacre on the site in 1985. In memory of the kidnap and death of a nurse, Salcedo sewed together thousands of preserved rose petals to create a cloth called *A Flor de Piel* — delicate and beautiful, yet a reminder of blood and suffering.

"Memory is the essence of my work."

The materials Salcedo uses for her art are cheap, signifying the poverty experienced by many of the people she commemorates. Although her work is inspired by tragedy, the painstaking care she takes to make it results in beauty. Salcedo says this is "perverse," but that beauty is the dignity the victims deserve.

CINDY SHERMAN

Born 1954

How should a photograph make you feel? Happy? Successful? Cindy Sherman doesn't think so. She takes pictures of herself that make us feel unsettled. For Cindy the "selfie" is not about looking good: it is a way of making you think.

Sherman grew up on Long Island, New York. She was much younger than her four siblings and often felt left out. This led to her habit of dressing up as someone else:

"I thought: if you don't like me like this maybe you will like me like this? With curly hair? Or like this?"

As an art student she would dress up for parties as a man, a pregnant woman, or a television star. Now, she transforms herself into characters for her highly sought-after photographs.

Her most famous series is sixty-nine black-and-white self-portraits called *Untitled Film Stills* casting herself as a woman in a variety of settings familiar from movies of the 1950s and 1960s. The expressions and poses often make her look lonely, uncertain, or vulnerable. They draw attention to the ways women have been depicted in film and television. Photographs carry all sorts of unspoken messages, and Sherman makes us aware of that.

Horror is her favorite genre, and she often uses its creepy imagery. With vivid color and special effects, she can equally disturb you as a garish clown or a dark character from an imagined fairy tale. By using herself as a model, she always raises the question of what is fake and what is real. In the process she has become one of the world's most influential contemporary artists.

Untitled A 1975

78

Who was your role model growing up?

To a certain extent, it was just women I'd see in the media, actresses in movies, moms on TV, women in magazines or the Sears, Roebuck catalogue. My mother was, too, I suppose, but she was an older mom when she had me, so I think I really looked to the younger women in the media.

What are your three top tips for becoming an artist?

· Try to forget everything you learned about making art.
· Find a group of like-minded artists or creative people to hang out with.
· Take chances with what you do, make things that no one but you will ever see, unless it turns out so good you want to share it.

If you weren't an artist, what would you be?

A gardener, farmer, or I'd have a thrift store.

Why do you make art?

It's my life and it's what I'm most passionate about. And it's fun!

What's the best piece of advice you've ever been given?

Find inspiration in reading (I'm a terrible reader)!

What were your favorite subjects at school?

Art and math.

LORNA SIMPSON

Born 1960

Lorna Simpson uses photography, video, collage, and painting to challenge ideas about gender, race, history, and desire.

A black woman in a white dress poses five times for the camera, under labels that list the days of the week. We don't see her face, but her folded arms could mean strength, or self-protection. Underneath are a series of words, all starting with "mis," and suggesting misunderstanding. They make us wonder: who is this woman? What do we know about her experience, and what do we think we know?

Simpson was born in Brooklyn, New York. In her teens she traveled around Europe, Africa, and the United States taking documentary photographs. However, later in her studies she realized that photographs are not necessarily as objective or informative as they seem. She began to add printed text to her pictures, and her art became more about ideas. For this reason she is known as a conceptual artist.

Simpson's photographs are of usually of women, but sometimes men. She also sources pictures from magazines and old photographs found in flea markets or bought online in her collages. By putting these images together she encourages us to look closer in order to understand and to think about how all people are represented. A painter, too, Simpson is a leading artist of her generation.

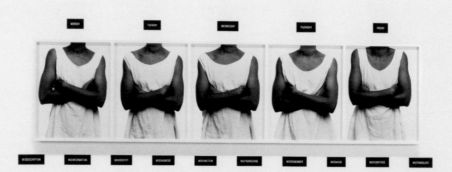

Five Day Forecast 1991

How did you get into making art?

I began making drawings and small sculptures as part of art classes in elementary school and attended a summer art program at the Art Institute of Chicago while I was visiting my grandmother. I always enjoyed spending time figuring out how to make things.

If you weren't an artist, what would you be?

As a child I was so adamantly persistent about the arts, be it dance, music, or visual arts, that I really never considered an activity that was not the arts. At the same time, I believed that there was a world of things that I could try, but when it came to making art — it always felt right. Hours spent working on something artistically would captivate me, and the time would pass quickly.

What's the best piece of advice you've ever been given?

Believe in yourself, and do what you deeply believe is the right thing for you to do. At times many people will not understand and that is okay.

What inspires you in your life?

My daughter and the beauty and challenges of day-to-day life. Other artists' work, books (fiction and nonfiction), politics, movies, news, new friends, and old friends who know me well.

How do you go about making an artwork?

Sometimes it's a lot of reflection about ideas that I write down in a journal, or it's just simply trying to imagine what I want to make. Sometimes it's a phrase, or an image. Once I have an idea, I play with different approaches to it, imagine different versions of it, and sometimes I will discard an idea or take it in another direction. That is the process of how an idea starts to evolve. Since I work in a lot of different mediums, sometimes the idea is for a film, or a painting, or photographs, or a series of collages or sculpture. It all depends on the nature of the idea. It is also really important to me to be in conversation with other people whom I trust.

Did you Know?

A photograph from Cindy Sherman's *Centerfold* series was sold at auction for $3.9 million in 2011. At the time it was the most expensive photograph ever sold.

The most expensive artwork by a woman so far is Georgia O'Keeffe's *Jimson Weed/White Flower No. 1*, which was sold for $44 million in 2014.

$44,000,000 2014

Louise Bourgeois worked as an English translator at the art school of the Sorbonne in Paris, so she could get free tuition, when her father refused to pay for it. (She had originally gone to the Sorbonne to study math.)

Sarah Lucas and Tracey Emin once ran a small shop together selling T-shirts with rude slogans.

Dorothea Tanning was a surrealist artist who also wrote poetry. Her last poems were published when she was one hundred years old, just a year before she died.

Yayoi Kusama is one of the most prolific artists working today. She lives in a hospital by night and works across the road in her Tokyo studio by day.

One of Cornelia Parker's artworks involved filling the Serpentine Gallery with glass cases with curious objects inside, including one of Queen Victoria's stockings and the actress Tilda Swinton pretending to be asleep.

Cindy Sherman failed her first photography course. (She passed the second one though.)

Dayanita Singh

Born 1961

Dayanita Singh is an artist who works with photographs. She lives and works in India, and her art has been exhibited around the world.

Singh chose photography as a career to find her freedom, away from society's expectations of marriage and family. She trained as a photojournalist but has since become interested in creating new ways of thinking about photography and making it available for people to see.

Despite living and working among the colorful sights of India, she usually works in black and white to create "something elusive" in her images. Her subjects vary from families at home to abandoned rooms full of paper to an outcast called Mona Ahmed living in a cemetery.

On a grand scale, Singh makes "mobile museums" for her photographs out of large, folding wooden structures containing moveable frames, so she can continually edit her work and display it in new ways. On a smaller scale she creates accordion books of photographs, which zigzag open and display the contents as miniature exhibitions.

Singh carefully decides every aspect of the books, from the paper they are printed on to the thread used to bind them, so that each piece is both a form of display and a work of art in itself. You can see her work in major galleries, but she has also put her books in shop windows and given them to strangers in the street. The way Singh shares her art is as original and important as the way she makes it.

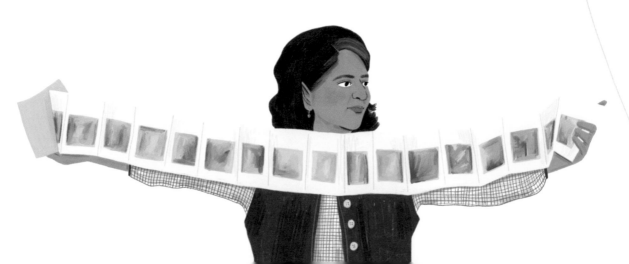

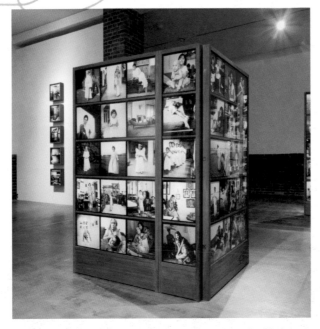

Little Ladies Museum 2013-15

Who was your role model growing up?

My father. He was always building rooms within rooms. We lived in an organic house.

How do you go about making your artworks?

I gather hundreds of photographs, edit them ruthlessly, and then sequence them. By then the form presents itself. Often I fail and start again.

What's your favorite medium, and why?

Photography, because it allows me to be free in the world. I document things around me and continuously find new forms for the material I gather, like a chef gathers good ingredients for the meal she will make.

Where do you get your inspiration?

In literature, in cinema, in music, and in conversation.

Describe your work in three words

Dissemination of image.

What advice would you give your twelve-year-old self?

Read as much as you can; build your inner library.

Gillian Wearing

Born 1963

In 2018, a statue of the suffragist Millicent Fawcett was erected in the UK's most prominent position: Parliament Square. It was the first statue there of a woman and *by* a woman. The artist who made it was Gillian Wearing.

Wearing is one of the Young British Artists (YBAs) who emerged in the 1990s. She won the Turner Prize—the UK's biggest art prize—in 1997.

Wearing has always been interested in showing the complicated inner lives of people. She has done this with photography and video, often using signs, masks, or lip-synching. She has even re-created snapshots as members of her family, with her own eyes peeking through the mask.

Recently she has designed statues of selected families for public places in Italy, Denmark, and her hometown of Birmingham. The Birmingham family is not a mother and father, but two sisters with their sons. Wearing knows there is a difference between what we think is "typical" and what we experience as true. Her art reflects this and makes us reflect on it too.

Self Portrait as My Brother Richard Wearing 2003

Did you always know you wanted to be an artist?

No, I had no ambition to be an artist when I was younger, although I did have a creative side. Growing up in 1970s Birmingham, there weren't many opportunities for jobs of any kind. I did try and apply to be a window dresser, but constantly got rejection letters. I ended up doing secretarial work, and while being a secretary in London saw animators painting on animation cels, so then I initially wanted to become an animator. While at art school I was told I had a fine art sensibility, one of the nicest things anyone had ever said to me up until that point. So I went with that suggestion.

Who was your role model growing up?

Punks were my role models. I was a punk, and it was such a DIY movement—it was the same with the generation of artists I went to art school with. It would have been unheard of for a young group of artists to have such visibility on leaving their degree courses, but I am sure some of this influence came from growing up and seeing young people join bands without any backing or institutional structure, during the punk years.

How do you go about making an artwork?

What medium I will use depends on the idea. It can be spontaneous or scripted.

Describe your work in three words

It's about portraiture.

What advice would you give to young artists?

Work hard and try things out.

If you could only save one artwork in the world, what would it be, and why?

Rembrandt's *Self Portrait at the Age of 63*. It is an honest portrait of an aging man, painted at his highest level of skill. The idea of physical decline is thwarted by the strength of his talent.

RACHEL WHITEREAD

Born 1963

Whiteread lives and works in London. Her sculptures are cast from everyday objects using materials like concrete or resin. She was one of the Young British Artists (YBAs), including Tracey Emin and Tacita Dean, who became famous in the 1990s. Whiteread works with the idea of negative space—the area inside, underneath, or around an object. By showing us an aspect of things that we normally take for granted, she makes us see them in a new way.

How did you start making art?

Art was always around! When I was very little, I wanted to be a doctor. I didn't want anything to do with art because my mom was an artist and you don't want to do what your mom does. But then when I got a little bit older I realized that art was the thing that I loved doing more than anything in the world. I didn't start studying art until I was well into high school. So, you know, I had to study hard to make up for lost time, but once I'd begun doing it, I absolutely loved it.

What is your favorite art medium and why?

My favorite medium now is probably still plaster. I like it because it's a little bit like magic. It starts off as a mineral that you mine from the earth, and then you grind it up to powder, put water with it, and it turns into liquid and you pour it into a mold and it gets very hot. Then you take the mold away and it gets cold again and hard. It's like a magical material. But I also still love drawing too.

Who is your role model?

Well that's quite a difficult question, and I will probably still say my mom. There are lots of famous artists such as Louise Bourgeois and Bruce Nauman. But I think if there were anyone who was to be a role model it would be my mom.

If you weren't an artist, what would you be?

Now I've thought long and hard about this! I would be, I think, a psychoanalyst, or an environmentalist, or a doctor. There are all sorts of things I'd like to be. Basically, fixing the brain, fixing the world, and fixing people. If there is a way of combining these three things then that's perfect. And that's why I think making art is important, because that helps do this and if we can get everyone to understand this we'll be well set for life.

Why do you think making art is important?

I think making art is important because it can excite people. It can relax people. It can communicate things to people. It can be political. It can be pretty. It can be ugly. Art can be lots and lots of things to lots of different people.

What advice would you give to your twelve-year-old self?

Work hard, be kind, and be true to yourself.

Whiteread can make sculptures as big as houses. In fact, she has made a sculpture out of a house.

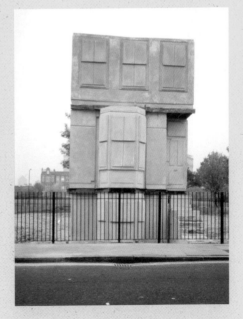

Untitled (House) 1993

Framing the Picture

COLLECTORS AND GALLERISTS

Who decides who is a "great" artist? The people who collect and display art have a big role to play, as well as the ones who make it.

Peggy Guggenheim

(1898–1979), American heiress and gallery owner, was friends with many great twentieth-century artists from Salvador Dalí to Lucian Freud. She rescued dozens of important paintings from Paris just before the Nazis invaded. You can visit her collection in her old palazzo in Venice overlooking the Grand Canal—one of the world's most beautiful museums of modern art.

Betty Parsons

(1900–1982) discovered and represented great abstract-expressionist painters including Mark Rothko, Jackson Pollock, and Agnes Martin. Her gallery supported many gay, lesbian, and bisexual artists, such as Jasper Johns and Robert Rauschenberg.

Clarissa Dalrymple

(born 1941) was born in Britain but works in New York. In 1992, she cocurated the first exhibition of Young British Artists (YBAs) in the United States.

Pamela J. Joyner

(born 1958) is a San Francisco–based collector and philanthropist who champions black artists and is on a mission to get them better recognition. She's a "cultural activist" of the art world.

Pearl Lam

(born c.1970) has galleries based in Hong Kong, Shanghai, and Singapore dedicated to exhibiting contemporary artists. Lam uses her exhibitions to break down barriers between art forms and between the cultures of East and West.

Sheikha Al-Mayassa bint Hamad bin Khalifa Al-Thani

(born 1983) has been called "the most influential person in art." She is the sister of Qatar's ruling Emir and chairperson of Qatar Museums. She wants to use the money she has to help create Qatar's cultural identity and share it with the wider world. She says, "We don't want to be all the same, but we do want to understand each other."

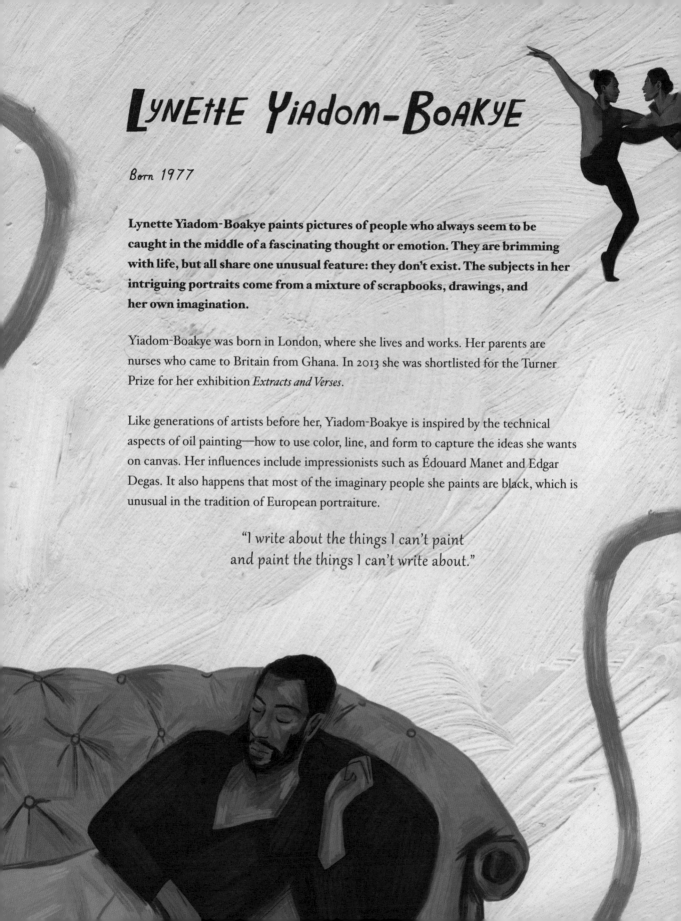

LYNETTE YIADOM-BOAKYE

Born 1977

Lynette Yiadom-Boakye paints pictures of people who always seem to be caught in the middle of a fascinating thought or emotion. They are brimming with life, but all share one unusual feature: they don't exist. The subjects in her intriguing portraits come from a mixture of scrapbooks, drawings, and her own imagination.

Yiadom-Boakye was born in London, where she lives and works. Her parents are nurses who came to Britain from Ghana. In 2013 she was shortlisted for the Turner Prize for her exhibition *Extracts and Verses*.

Like generations of artists before her, Yiadom-Boakye is inspired by the technical aspects of oil painting—how to use color, line, and form to capture the ideas she wants on canvas. Her influences include impressionists such as Édouard Manet and Edgar Degas. It also happens that most of the imaginary people she paints are black, which is unusual in the tradition of European portraiture.

"I write about the things I can't paint and paint the things I can't write about."

Yiadom-Boakye writes poems and short stories, and there is a sense of narrative about her paintings too. The titles are intriguing, such as *10 pm Saturday* or *Nowhere that Should Matter*. She says these mean something to her, but it won't be obvious to the viewer. She likes to paint each picture in a single day, using a technique in oils called "wet on wet." when a new color is applied before the last has had a chance to dry. In this way she can keep the inspiration for the painting fresh in her mind.

10pm Saturday 2012

In a generation brought up on conceptual art and installations, her focus on figurative paintings of people is quite rare. This, combined with her imaginary subjects and the half-told stories they suggest, makes Yiadom-Boakye's work stand out. She is not only painting black faces in an art world dominated by white ones but also creating intriguing images of people you want to know more about.

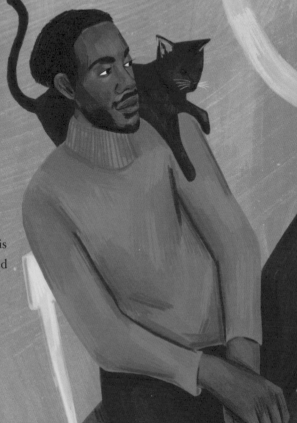

Fahrelnissa Zeid

1901 - 1991

What do you do if you are a well-traveled princess, but prone to depression, your father and your husband's family are murdered, and one of your sons dies of scarlet fever? If you are Fahrelnissa Zeid, you make art.

Zeid grew up in Turkey, the Muslim daughter of a Turkish father and a Greek mother, in a large, artistic family. She was one of the first women to study art in Istanbul and went to Venice for her honeymoon, where she discovered Western art. She was always interested in modern artistic advances. However it was when she first flew over Baghdad that she made her big discovery:

"Flying by plane transformed me . . . The world is upside down. A whole city could be held in your hand: the world seen from above."

Zeid developed a unique, kaleidoscopic style, fusing Byzantine, Persian, and Oriental influences with what she had learned from cubism and futurism in France. The results are detailed, abstract paintings, rich with color, like stained-glass windows or a bright scene viewed through a lattice screen.

Zeid's second husband was a diplomat and a member of the Iraqi royal family. With him, she lived in Paris, Baghdad, and London, and worked and exhibited wherever she went. While he was Ambassador of Iraq to the United Kingdom, Zeid turned one of the rooms in the embassy into her studio. They were banished from the embassy after a coup that killed much of her husband's family in Iraq. Zeid moved to a flat, cooked her first meal at age fifty-seven, and started making art out of the turkey bones.

In later life, she developed her interest in portraiture and created another distinctive style. She moved to Jordan in the 1970s and set up her own art institute, where she mentored young female artists until she died at the age of ninety. Her work was prized there and in Turkey, but otherwise forgotten, despite the many exhibitions in her lifetime. A large retrospective of her paintings at Tate in 2017 allowed many new fans to discover her vast and vivid canvasses.

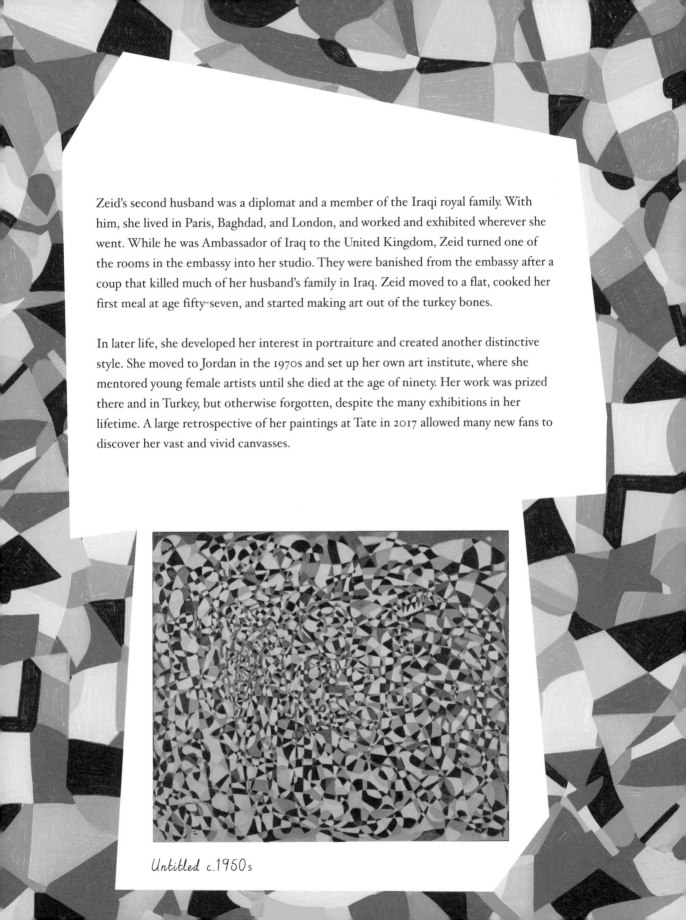

Untitled c.1950s

Culture is the story of everyone and how can you really tell the story of a culture when you don't include all the voices within the culture . . .

Guerrilla Girls

Artists are inspirational because they see the world in new ways.
They challenge what we take for granted and make us look, and look again.

It takes great bravery to do this, and persistence.
It takes time, too, to discover your vision and refine it. Many of the artists
in this book took years to discover what they wanted to say. Others found
their path early but often encountered many obstacles before they were
successful. What marks them out is that art was the way they needed
to express themselves, and they never gave up!

Many living artists have kindly contributed interviews to this book.
We hope their words and creativity have inspired you.

Great artists are unique. Their work challenges everyday ideas—what
do we consider to be beautiful? What do we consider to be normal?
They can create miniature paintings or massive sculptures.
They come from every corner of the globe and can be successful
in their lifetime or only long after death.

Once you've looked at the work of a great artist, you never see the
world in quite the same way again. Artists study other artists.
Check out the work and see where your inspiration takes you.

Good luck!

The world can never have enough artists.
Or enough people who are inspired by art.

QUIZ

1. Which artist painted her surgical corsets?

2. Which artist nearly qualified for her country's Olympic swimming team?

3. Who exhibited her messy bed?

4. Who was called a "lunatic, crazed with ambition"?

5. Who said, "Men put me down as 'the best woman painter.' I think I'm one of the best painters"?

6. Who made enormous spiders?

7. What is Yayoi Kusama the "princess" of?

8. Who wrote, "Shuffle the cards. Masculine? Feminine? It depends on the situation"?

9. How many people collaborated with Judy Chicago to make *The Dinner Party*?

10. Who dressed up as a pregnant woman or a TV star to go to parties?

11. Who was the first black female artist to win the Turner Prize?

12. Who made holes in her sculptures?

13. Who painted her face with flowers?

14. Who made a special hat for eating soup?

15. Who made necklaces out of book pages for her friends?

16. Whose love letters were hidden in a cupboard?

17. Whose paintings undulate and ripple in front of your eyes?

18. Who paints many of her pictures in just one day?

19. Who studied weaving at Bauhaus School of Design?

20. Who made a giant crack in the floor of Tate Modern's Turbine Hall?

Quiz answers

1. Frida Kahlo 2. Agnes Martin 3. Tracey Emin 4. Berthe Morisot 5. Georgia O'Keeffe
6. Louise Bourgeois 7. Polka dots 8. Claude Cahun 9. Nearly 400 10. Cindy Sherman
11. Lubaina Himid 12. Barbara Hepworth 13. Natalia Goncharova 14. Eileen Agar 15. Simryn Gill
16. Gwen John 17. Bridget Riley 18. Lynette Yiadom-Boakye 19. Anni Albers 20. Doris Salcedo

99

ART TERMS

Abstract art
Art that doesn't attempt to accurately depict reality but instead uses shapes, colors, forms, and gestural marks.

Abstract expressionism
A form of abstract art developed by American painters in the 1940s and 1950s. It is often characterized by gestural brushstrokes or mark-making, and the impression of spontaneity.

Activist art
Art that is grounded in the act of "doing" and addresses political or social issues.

Avant-garde
This kind of art is ahead of its time and explores new forms or subject matter.

Body art
Where the human body, often the artist's, is the principal medium and focus.

British black arts movement
A radical political art movement founded in 1982 which highlighted issues of race, gender, and the representation of people of color in art.

Classicism
A term used to describe art that makes reference to ancient Greek or Roman styles.

Conceptual art
This is when the idea (or concept) behind the work is more important than the finished art object.

Contemporary art
Art of the present day and of the relatively recent past.

Cubism
A revolutionary approach to representing reality invented in around 1907–1908. Cubists put different views together in the same picture, making their paintings appear fragmented.

ART TERMS

FEMINIST ART
Art made during the developments of feminist art theory in the early 1970s.

FIGURATIVE ART
Any form of modern art that has strong references to the real world, especially the human figure.

FOUND OBJECTS
Natural or human-made objects, or fragments of objects, that are found by the artist.

FUTURISM
An Italian art movement of the early twentieth century that aimed to capture the energy of the modern world in art.

GENRE
In painting, this term refers to paintings that depict scenes of everyday life.

IMPRESSIONISM
Developed in France in the nineteenth century, impressionism is based on the practice of painting outdoors and "on the spot," rather than in a studio from sketches.

INSTALLATION
A large-scale, mixed-media construction, often designed for a specific place or for a temporary period of time.

LAND ART
Art that is made directly in the landscape, sculpting the land itself into earthworks or making structures in the landscape using natural materials such as rocks or twigs.

LITHOGRAPHY
A printing process that uses a flat stone or metal plate on which the image areas are rubbed using a greasy substance so that the ink will adhere to them, while the non-image areas are made ink-repellent.

ART TERMS

MINIMALISM
An extreme form of abstract art developed in the United States in the 1960s that is normally based on simple shapes.

MIXED MEDIA
A term used to describe artworks composed from a combination of different media or materials.

MODERNISM
A global movement in society and culture that tried to reflect the experience and values of modern industrial life during the early twentieth century.

MULTIMEDIA
Artworks that are made from a range of materials and include an electronic element such as audio or video.

MUSE
A person (or people) who provide creative inspiration for an artist.

NATURALISM
A style of artwork that aims to reflect the subject factually and realistically.

NEOCLASSICISM
Neoclassicism was a particularly pure form of classicism that emerged in about 1750.

OP ART
The name given to the art movement launched by the *Responsive Eye* exhibition at MoMA in 1965, featuring Bridget Riley. It is short for "optical art."

PERFORMANCE ART
Artworks that are created through actions performed by the artist or other participants, which may be live or recorded, spontaneous or scripted.

PHOTOGRAPHY
The process or practice of creating a photograph—an image produced by the action of light on a light-sensitive material.

ART TERMS

PHOTOMONTAGE
A photomontage is a collage constructed from photographs.

POP ART
A movement that emerged in the 1950s in the United States and Britain, drawing inspiration from popular culture such as television shows and advertisements. Different cultures and countries contributed to the movement during the 1960s and 1970s.

PORTRAIT
A representation of a particular person. A self-portrait is a portrait of the artist by the artist.

POSTMODERNISM
This was a reaction against the ideas and values of modernism. The term is associated with skepticism about the idea that there is one universal way to look at things.

PRIMITIVISM
This term is used to describe the fascination of European artists with what was then called "primitive" art — including tribal art from Africa, the South Pacific, and Indonesia, as well as prehistoric and very early European art, and European folk art.

SCULPTURE
Three-dimensional art made by one of four basic processes: carving, modeling, casting, or constructing.

SURREALISM
A twentieth-century literary, philosophical, and artistic movement that explored the workings of the mind, championing the irrational, the poetic, and the revolutionary.

VIDEO ART
Art that involves the use of video and/or audio data and relies on moving pictures.

For lots more information on art terms visit: tate.org.uk/art/art-terms

TIMELINE

51 BC
Cleopatra VII becomes coruler of Egypt

1558
Queen Elizabeth I becomes queen of England

1792
Mary Wollstonecraft writes *A Vindication of the Rights of Woman*

1841
Berthe Morisot is born

1843
Ada Lovelace publishes an algorithm to make the first computer

1848
First women's rights convention is held in New York

1851
Sojourner Truth delivers her famous speech, "Ain't I a Woman?"

1899
Anni Albers born

1901
Fahrelnissa Zeid born

1903
Barbara Hepworth born

1903
Marie Curie is the first woman to be awarded the Nobel Prize

1907
Frida Kahlo born

1911
First celebration of International Women's Day

1911
Louise Bourgeois born

1912
Agnes Martin born

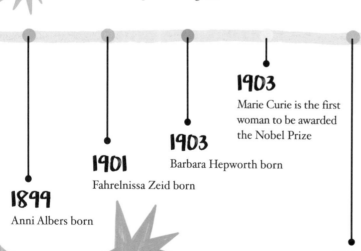

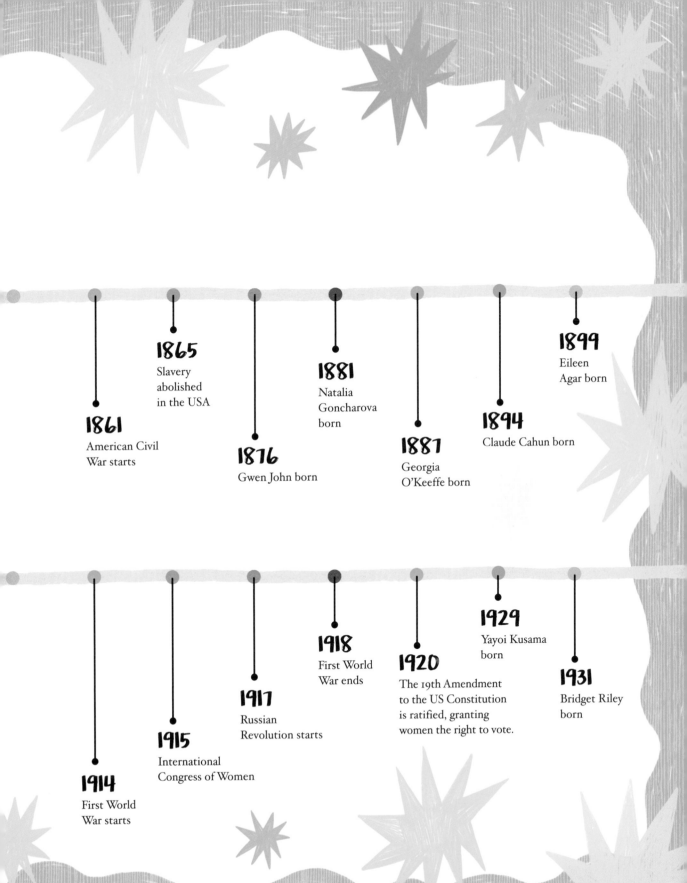

1861
American Civil
War starts

1865
Slavery
abolished
in the USA

1876
Gwen John born

1881
Natalia
Goncharova
born

1887
Georgia
O'Keeffe born

1894
Claude Cahun born

1899
Eileen
Agar born

1914
First World
War starts

1915
International
Congress of Women

1917
Russian
Revolution starts

1918
First World
War ends

1920
The 19th Amendment
to the US Constitution
is ratified, granting
women the right to vote.

1929
Yayoi Kusama
born

1931
Bridget Riley
born

TIMELINE

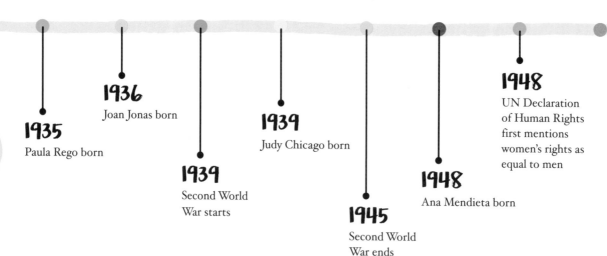

1935
Paula Rego born

1936
Joan Jonas born

1939
Second World
War starts

1939
Judy Chicago born

1945
Second World
War ends

1948
Ana Mendieta born

1948
UN Declaration
of Human Rights
first mentions
women's rights as
equal to men

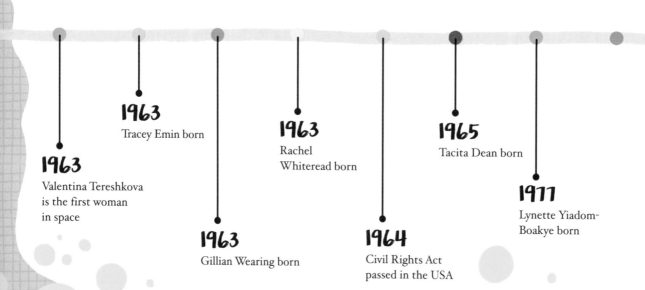

1963
Valentina Tereshkova
is the first woman
in space

1963
Tracey Emin born

1963
Gillian Wearing born

1963
Rachel
Whiteread born

1964
Civil Rights Act
passed in the USA

1965
Tacita Dean born

1977
Lynette Yiadom-
Boakye born

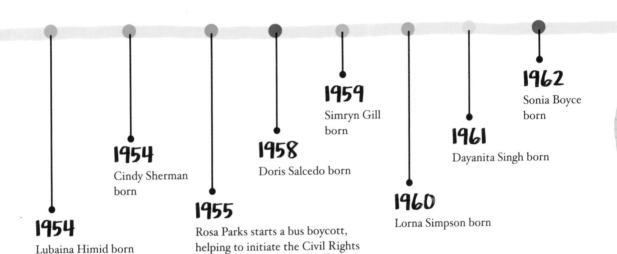

1954
Lubaina Himid born

1954
Cindy Sherman born

1955
Rosa Parks starts a bus boycott, helping to initiate the Civil Rights movement in the USA

1958
Doris Salcedo born

1959
Simryn Gill born

1960
Lorna Simpson born

1961
Dayanita Singh born

1962
Sonia Boyce born

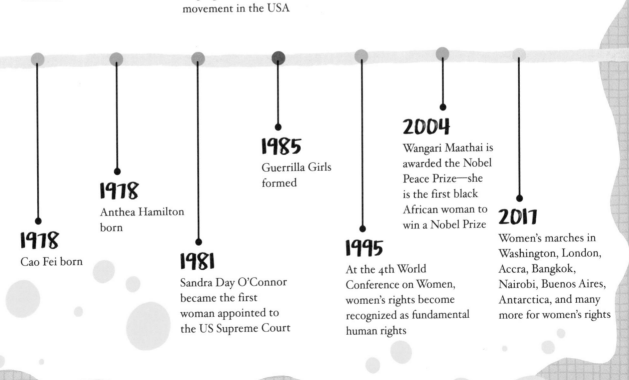

1978
Cao Fei born

1978
Anthea Hamilton born

1981
Sandra Day O'Connor became the first woman appointed to the US Supreme Court

1985
Guerrilla Girls formed

1995
At the 4th World Conference on Women, women's rights become recognized as fundamental human rights

2004
Wangari Maathai is awarded the Nobel Peace Prize—she is the first black African woman to win a Nobel Prize

2017
Women's marches in Washington, London, Accra, Bangkok, Nairobi, Buenos Aires, Antarctica, and many more for women's rights

CREDITS

Suggested Websites

The Art Story

Artsy

artnet News

Dazed

RA

Guggenheim

IdeelArt

The New Yorker

Musee d'Orsay

MoMA website

New York Review
of Books

The Art Newspaper

V&A

Art Basel

Art Space

PBS

Apollo Magazine

Saatchi Gallery

Encyclopedia
Britannica

Tate

Selected Bibliography

Articles

Artlyst. "Cindy Sherman $3.89m Record Price for Photograph." May 25, 2011. artlyst.com/news/cindy-sherman-389m-record-price-for-photograph/.

Baumgardner, Julie. "A New Show by Artist Lorna Simpson Summons Fire, Ice and History in Reverse." *Wallpaper*, February 28, 2018. wallpaper.com/art/lorna-simpson-hauser-wirth-london.

Campbell, Peter. "About to be at Tate Britain, or Meanwhile in Cork Street." *London Review of Books*, October 7, 2004. lrb.co.uk/v26/n19/peter-campbell/about-to-be-at-tate-britain-or-meanwhile-in-cork-street.

Davies, Ashley. "Tracey Emin." *Guardian*, October 11, 2002. theguardian.com/news/2002/oct/11/netnotes.ashleydavies.

Knowles, Beverley. "Louise Bourgeois at Freud Museum." This Is Tomorrow, May 21, 2012. thisistomorrow.info/articles/louise-bourgeois-the-return-of-the-repressed.

Laing, Olivia. "Agnes Martin: The Artist Mystic Who Disappeared into the Desert." *Guardian*, May 22, 2015. theguardian.com/artanddesign/2015/may/22/agnes-martin-the-artist-mystic-who-disappeared-into-the-desert.

Lamberg, Lynne. "Artist Describes How Art Saved Her Life." American Psychiatric Association, September, 14, 2017. psychnews.psychiatryonline.org/doi/full/10.1176/appi.pn.2017.9a21.

McNay, Michael. "Louise Bourgeois Obituary." *Guardian*, May 31, 2010. theguardian.com/artanddesign/2010/may/31/louise-bourgeois-obituary-art.

Rile, Karen. "Georgia O'Keeffe and the $44 Million Jimson Weed." JSTOR Daily, December 1, 2014. daily.jstor.org/georgia-okeeffe-and-the-44-million-jimson-weed/.

Tate. "Five Things to Know: Joan Jonas." n.d. tate.org.uk/art/artists/joan-jonas-7726/five-things-know-joan-jonas.

Tate. "Rachel Whiteread: Untitled (Air Bed II)." n.d. tate.org.uk/art/artworks/whiteread-untitled-air-bed-ii-t06731.

Tate. "Room 5: Preparatory Work." n.d. tate.org.uk/whats-on/tate-britain/exhibition/bridget-riley/bridget-riley-room-guide-room-5-preparatory-work.

Telegraph. "The New Mexico Landscapes That Inspired Georgia O'Keeffe." July 4, 2016. telegraph.co.uk/travel/destinations/north-america/united-states/articles/new-mexico-landscapes-that-inspired-georgia-okeeffe/.

Schjeldahl, Peter. "Agnes Martin, a Matter-of-Fact Mystic." *New Yorker,* October 10, 2016. newyorker.com/magazine/2016/10/17/agnes-martin-a-matter-of-fact-mystic.

Secher, Benjamin. "Paula Rego: 'It's horrible to be so old and still so afraid.'" *Telegraph*, October 2, 2016. telegraph.co.uk/art/artists/paula-rego-its-horrible-to-be-so-old-and-still-so-afraid/.

Books

Foster, Alicia. *Tate Women Artists*. New York: Abrams, 2003.

Rideal, Liz, and Kathleen Soriano. *Madam & Eve: Women Portraying Women*. London: Laurence King, 2018.

Roe, Sue. *Gwen John: A Life*. London: Vintage, 2002.

Roe, Sue. *The Private Lives of the Impressionists*. New York: HarperCollins, 2007.

Weidemann, Christiane. *50 Women Artists You Should Know*. New York: Prestel, 2016.

ABOUT THE AUTHOR

Sophia Bennett has written several books for children.
Her novels tell the adventures of creative young
people in the worlds of fashion, music, and art, and
they have been translated into over a dozen languages.
She is the winner of the Times/Chicken House
Competition and the Romantic Novel of the Year, and
has been shortlisted for BookTrust's Best Book Award.

Amanda Craig, writing in the *Times*, called her
"the queen of teen dreams."

Sophia lives in London, so she can be as close to as many
art galleries as possible. *Women's Art Work: More Than Thirty Female
Artists Who Changed the World* is her first work of nonfiction.

ABOUT THE ILLUSTRATOR

Manjit Thapp is an illustrator based in the UK.
She graduated from Camberwell College of Arts
in 2016, where she studied illustration. Her work
combines digital and traditional media and much
of it revolves around female characters.

She creates artwork that evokes a particular feeling and
atmosphere that can be interpreted by the viewer.
She balances working on both commission and personal
work with clients that include Penguin Random House,
Google, Apple, Adobe, and Stylist. Her work has been
featured in *British Vogue*, *Vogue India*, *Wonderland*, *Dazed,*
and on Instagram.

INdex